JOSH SIMPSON

GLASS ARTIST

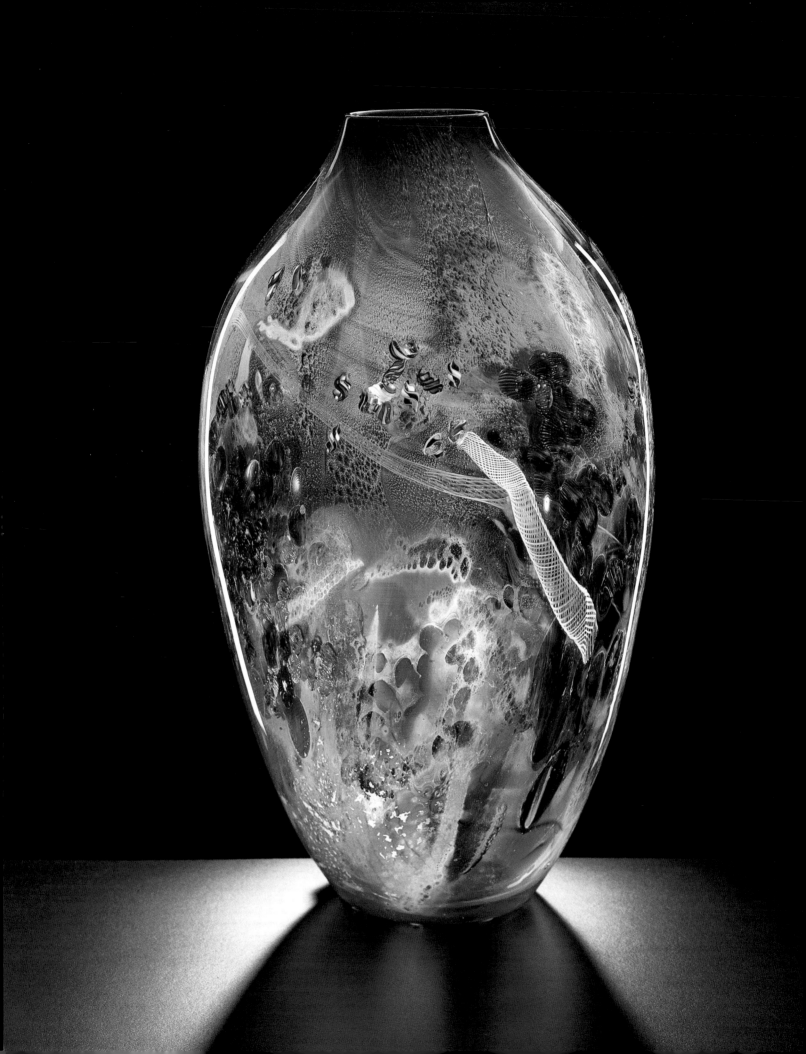

JOSH SIMPSON
GLASS ARTIST

Andrew Chaikin

GUILD PUBLISHING · MADISON, WISCONSIN
Distributed by North Light Books, Cincinnati, Ohio

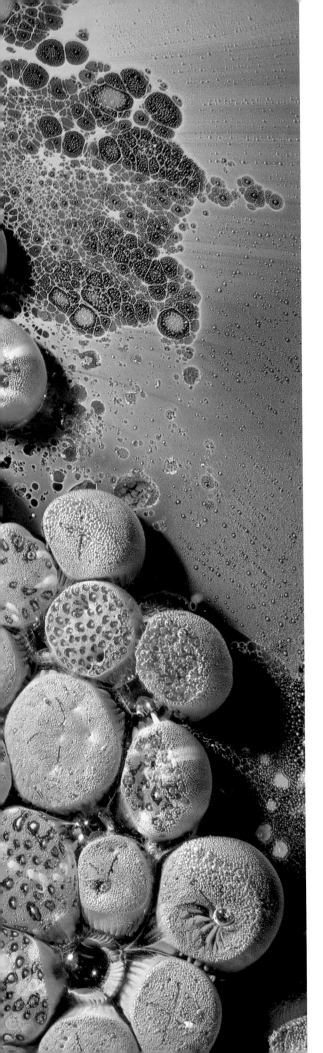

JOSH SIMPSON
Glass Artist

Copyright © 2001 by GUILD Publishing, an imprint of GUILD.com

Cover and interior design: Lindgren/Fuller Design
Project coordinator/ Josh Simpson Contemporary Glass: Karen Krieger
Chief editorial officer: Katie Kazan
Editorial manager: Dawn Barker
Editorial assistance from Nikki Muenchow and Judy Morris

01 02 03 04 7 6 5 4 3 2 1

Published by
GUILD Publishing
An imprint of GUILD.com, Inc.
931 E. Main Street
Madison, WI 53703 USA
TEL 608-257-2590 · TEL 877-284-8453 · FAX 608-227-4179

Distributed to the trade and art markets in North America by North Light Books
An imprint of F&W Publications, Inc.
1507 Dana Avenue
Cincinnati, OH 45207
TEL 800-289-0963

Printed in China

ISBN: 1-893164-09-8

PHOTOGRAPHY CREDITS
Cady Coleman: pages 27 (top), 32 ▪ Tommy Olof Elder: front cover, back cover, back flap, frontispiece, this page, 34, 61, 63, 65 (bottom), 67, 68, 69, 70 (bottom), 71 (bottom), 74, 76, 79, 82, 84 (bottom), 85, 86, 87, 88, 89, 90 (bottom), 93, 95, 96, 99, 100 (bottom right), 101, 103 (top right and bottom), 104, 105, 106, 107, 108, 109 (top), 110 (top right and bottom), 111, 112, 113, 114, 115, 116, 117, 119, 120, 121 ▪ Matt Foley, 10 ▪ Nicholas Sant Foster: 39, 98 (main image) ▪ Karen Krieger: 6, 26 (top) ▪ Lewis Legbreaker: 16, 21, 35, 36, 37, 62-63, 65 (top), 66, 70 (top), 71 (top), 73, 75, 78, 80, 81, 83, 84 (top), 91, 92 (top right and bottom), 94 (bottom), 98 (inset), 102, 103 (top left), 109 (bottom), 110 (top left), 124, 126 (left) ▪ Scott Lesure: 25, 48, 49 (top, bottom left), 55, 57 (center), 59 (top left and bottom left) ▪ Robert Harbison: 43, 45, 46, 47, 50, 51, 52, 53, 56, 57 (top and bottom), 58, 59 (top right and bottom right), 60 ▪ Josh Simpson: 14, 15, 17, 22, 23, 24, 26 (bottom), 27 (bottom), 28, 29, 40, 41, 42, 49 (bottom right), 68, 77, 100 (top and bottom left), 126 (right)

CONTENTS

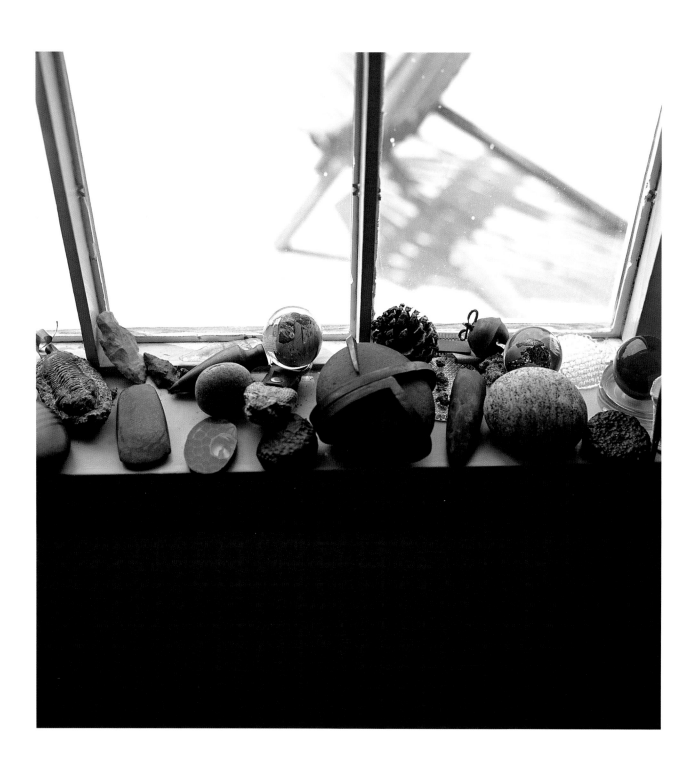

FOREWORD

GLASS: AN INVITING, PARADOXICAL MEDIUM BOTH IN ITS HOT-MOLTEN-becoming state and its cooled final form. No art makes a greater demand on the discerning eye than that of the glassblower, and few offer richer rewards for the attention given.

Four thousand years of history reveal man's fascination with the mystery and visual richness of glass—absorbing, modulating, bending, refracting and reflecting light. This harmony and resonance between states of molten fluency and frozen permanence has tempted glassblowers from the beginning. The ancients treasured its rare, fragile beauty as equal to gold itself.

The beauty of glass and its functionality led man to develop and refine the chemicals, tools, furnaces and ovens necessary to perfect the craft of glassmaking. The 20th century brought new technological possibilities, enabling glass to be mass-produced and widely available. Along with the advantages of mass-producing useful glass objects, a major disadvantage arose: glass as art form was obscured by a machine mentality.

During the past 35 years, a departure from product-oriented commercial glassmaking has occurred. In commercial work, an artist/designer creates a

Kitchen windowsill in Simpson residence, with fossils, arrowheads, tektite meteor, planet flown aboard the space shuttle *Columbia*, microchip, sleigh bell, titanium metal chip from Russian proton rocket and rattlesnake head.

design on paper, which is then translated into three-dimensional form by a technician. The artist is separated from the making process. In the present revival of glassmaking as art, the artist is once again with his craft, literally breathing form into the mass of hot-molten glass, which he holds at arm's length.

...to preserve, within a given form, the robust nobility of the hot, thick glass ready to be blown, and while blowing it, to let the nature of the glass assert itself, to control its natural tendencies without denying them: while the glass is at the height of its incandescence, to coax from its forms that art plump and yielding, and then to incorporate into them other pieces evoking still or running water, or crackling and melting ice.

Maurice Marinot (1882–1960)
French painter and glassblower

Josh Simpson is a prime example of an artist who chooses to confront this demanding, paradoxical medium with his own vitality, passion, intellect and skill. Acting and reacting...acting and reacting, he is in daily pursuit of the essence of his craft, attempting not only to probe and question the definitions and standards of the past, but also to open himself to the improvisational possibilities of glass.

The early works in Simpson's oeuvre are primarily goblets, tumblers, spherical weights, platters, vases and perfume bottles—all recognizably related to everyday functional glass shapes. Rather than agonizing over questions of form and function that plague many craft artists, Simpson preferred not to transcend or to supersede these basic shapes, but instead used them as springboards for explorations in design and color.

The glass works presented in this volume focus on Simpson's later explorations and represent a shift from functional considerations to purely sculptural forms. Looking at his recent series, which the artist has titled *Planets, Tektites, Megaworlds, Saturns* and *Portals,* it becomes apparent that Simpson's personal aesthetic and passion reside in the cosmic universe and the natural

world. Looking like fragments from the big bang and pieces of nature's offspring, Simpson's sculptures capture the process of making, thereby reinforcing their implicit sense of life. The magic and alchemy inherent in molten glass, with its gorgeous and perennially cool appearance, provide Simpson with the means to express the wonder and mystery of the universe. A majority of the pieces feature simple but sure forms that allow the artist to focus his energies into the internal regions of the spheres. Simpson's virtuoso execution of complex interior illusionary worlds and glowing miniature landscapes are further heightened by magnification resulting from the outermost and final layer of clear glass. Observing these universes unto themselves, we thrill at our sense of discovery of a glowing imaginary world—densely packed with richly colored and textured surfaces captured in a state of permanent fluidity—and we recognize that the very process of making reinforces an implicit sense of life. In Simpson's glass, idea, technique and form are truly integrated and become one.

Simpson's planets are not meant to alert us to ecological issues, but neither are they immune to such associations. Instead, they effectively remind us of the awe we feel in the presence of nature and the vulnerability of man and Earth. Josh Simpson's glass sculptures gleam with light and affirmation. For this, we are thankful.

Michael W. Monroe

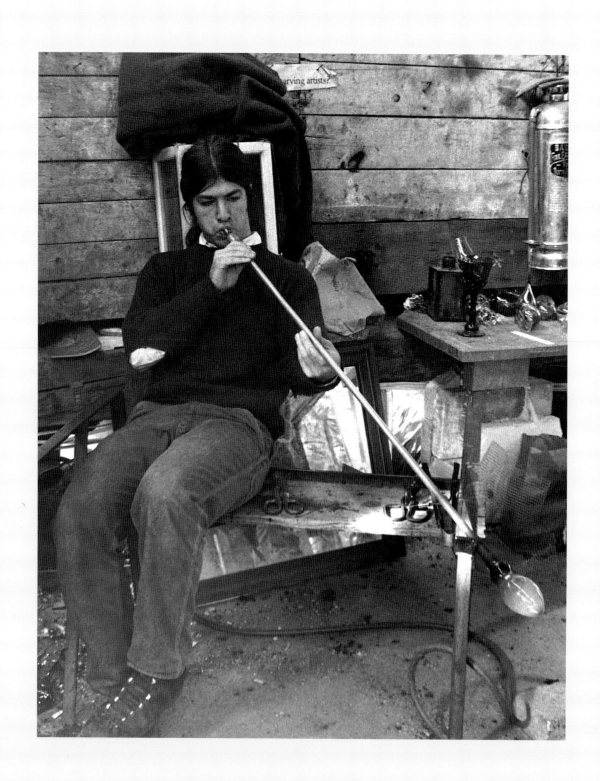

PORTRAIT OF THE ARTIST
TO INFINITY AND BEYOND

Josh Simpson was 11 years old the year everything changed for Earthlings. In 1961, a young Russian pilot named Yuri Gagarin became the first person to orbit Earth. For anyone who stopped to ponder it, the news brought a stunning realization. Suddenly, the human species was not confined to the planet of its origin. Earth had become a jumping-off point for a grand and endless journey into the cosmos. This awakening did not catch Josh Simpson by surprise: it was already inside him.

Simpson grew up in the small town of South Salem, New York, whose rural setting belied its proximity to Manhattan. It was a big deal whenever his parents took the children to "the city"; for Simpson the most wonderful destination there was the Hayden Planetarium of the American Museum of Natural History.

Blowing glass in Vermont studio, 1972.

Within its Art Deco halls, you could check what you would weigh on other planets. You could touch a huge iron meteorite, its skin charred from its fiery plunge through the atmosphere. You could stand in front of a glowing panorama of a lunar landscape and see Earth suspended before you in the blackness of space.

It didn't take many of those trips to make a place for other worlds in Simpson's imagination. The boy's fascination led him to the pages of science fiction stories. There were other worlds, too, in his own room, where he began raising tropical fish. He found himself looking into the fish tank and seeing a microcosm, a self-contained world of earth and watery sky. And he found himself wondering what it would be like to be one of those swimming creatures, for whom the universe ended at a flat pane of glass.

And then there was the space program. To have the good fortune to be growing up during the first space missions, when NASA was aiming for the moon — it was enough to make any boyhood seem magical. Simpson was totally absorbed in the pioneering missions of the Mercury astronauts. The closest he himself got to outer space was when he would climb to the very top of the nearest large tree. And on nights when the moon shone down, Simpson would sometimes sit on the porch with his dad, discussing what might be involved in constructing a homemade telescope.

That was one project father and son didn't tackle — but there were plenty of other things to do. What Jim Simpson did for a living — he was a contracts administrator — held little interest for the boy, but the time they had together was filled with adventures. He would take Josh to the nearby Croton train yards, where they would climb underneath the giant steam locomotives. In their house in South Salem there was the basement tool shop, where Jim Simpson gave his son the freedom to experiment with power tools (a practice that could be nerve-wracking for Josh's mother, Norma). And there were homegrown science and engineering projects.

To be sure, some of Simpson's experiments had unintended consequences. One day when his parents were out, he filled a Coke bottle with

water and added a healthy amount of dry ice. Then he capped it, using a device his dad had created for half-full soda bottles. He watched in fascination as the sealed contents boiled and smoked, as the ice turned to carbon dioxide gas. Then the ice was all gone, and suddenly the water turned clear again; it had absorbed the gas. Disappointed, he took the bottle outside, tossed it away, and walked back inside. After a minute or so, a tremendous explosion shattered the back window of the house. Simpson spent the rest of the afternoon prying shards of glass out of the wooden shingles. He told his parents that he'd broken the window with a baseball.

When Simpson was in 10th grade, his parents sent him to an Episcopal boarding school. Six days a week, the day began with a pre-breakfast church service at which attendance was mandatory. It was easier to avoid the two-hour Sunday mass, where there were many visitors, and Simpson sought his own safe haven on Sundays. Escape to his room was impossible — a squad of students checked the dorms for stragglers — but finally, in his senior year, Simpson found sanctuary. He was in charge of keeping the art room clean and had been given a key to a large storage room beside it, where, he realized, he could hide during Sunday mass. The trick was figuring out what to do there for the two hours he had to kill before it was safe to go to breakfast. Finally, he found an old potter's wheel and some clay and taught himself to throw pottery.

But it wasn't until early 1972, during his senior year at Hamilton College, that Simpson stumbled onto the medium that would become his career. Seniors were encouraged to take the month of January, Simpson remembers, "to do anything they wanted, as long as it was academically redeeming." Simpson had heard that a glassblowing furnace existed nearby at Vermont's Goddard College, and he convinced a dean that glassblowing would make a fine January project. When he arrived at Goddard, however, things didn't go as he'd planned. "The

Simpson's first studio, 1972, Plainfield, Vermont.

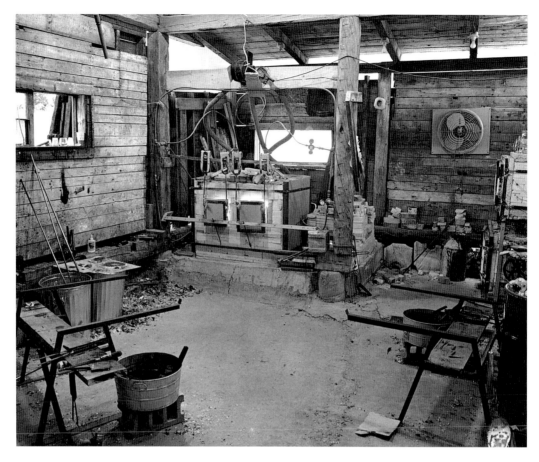

Interior of Vermont studio, 1972.

glass furnaces had burned out and been dismantled," he recalls, "and the college had no intention of replacing them." But Simpson, ever the optimist, decided to hang around, and after a couple of days he met other students who shared his interest. Soon, they were blowing glass with a furnace they had constructed from recycled bricks.

There was nothing halfway about Simpson's reaction to his first glass-blowing experience. "I just fell in love. I was pretty terrible, but I thought I was amazingly good at it." He wanted more. In fact, he wanted not to return to Hamilton at the end of January, but to spend the next year learning the art he had just discovered. He knew this would not please his parents — with just one semester to go until graduation, he would be putting college on hold — and he couldn't be sure how the officials at Hamilton would react.

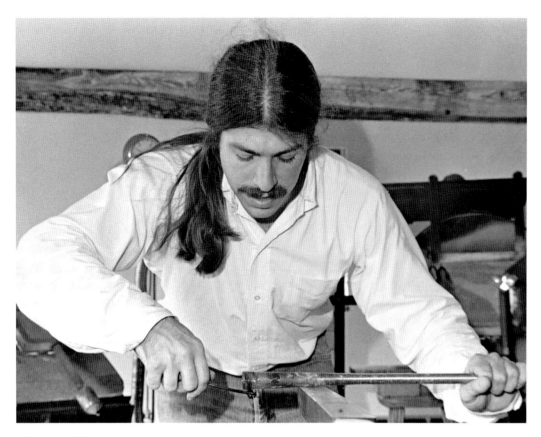

Cleaning a blowpipe, 1976.

There was one other potential snag: the Vietnam War was still raging, and as a college-age male, Simpson was eminently draftable. He didn't want to fight; he also knew he wouldn't go to Canada to avoid being drafted. Even before he made his January excursion to Goddard College, Simpson decided he didn't want the matter hanging over him. His draft number was 145, and he decided to take a calculated risk: he called the New York State draft board and gave up his student deferment. By late December, they had gotten perilously close to Simpson's number, but the year ended before they reached it. He had arrived at Goddard with the knowledge that his direction in life was his own to choose. And when he returned to Hamilton after his month-long glassblowing experience, he was granted permission to take the next year off.

He now calls that year "the best and worst thing I ever did." He lived with his dog in a canvas teepee that he built in the woods and heated with a

wood stove. With almost no human contact, without even a radio to connect himself to the events of 1973, Simpson experienced an isolation he had never known. He also enjoyed a time of ongoing discovery, developing his style as a glassblower and craftsman. Most of the time, experience was his teacher. Sometimes, though, he would make the drive to the Corning Glass Company

in upstate New York. There, the scientists received him graciously — this young man who lived in a teepee and smelled of wood smoke. As they answered his questions, they seemed to say, "We're struggling to solve the difficulties of working with glass, just as you are." By the time the next January arrived, Simpson knew he had found his calling.

After returning to Hamilton to complete his degree in psychology, Simpson moved to Connecticut, intending to build a glass studio on property his grandfather owned north of New Haven. One thing stood in his way: the banks he approached wouldn't loan him the money to do it. They'd never heard of anyone making a living blowing glass, and it wasn't until he showed samples of his work at the crafts fair in Rhinebeck, New York, and returned to Connecticut with $5,000 worth of orders, that they gave him a loan. By the fall of 1974, his studio was a reality. Soon he was not only blowing glass, but supporting himself with his craft.

Simpson had been in business for more than a year when his grandfather's death forced him to leave his Connecticut studio. In the spring of 1976, he moved to Shelburne Falls, bought a 10-acre farm, and made western Massachusetts his home. He immediately turned his energies toward creating a studio out of the old barn. But as a place to live, the property had some distance to go. The house, which had been built in 1802, was run-down. To make the place

feel more like home, Simpson decided to plant some flowers. He was digging beds one day when he discovered a handful of marbles.

Finding the marbles brought him back to his boyhood and the many times he had held marbles in his hand and wondered how in the world someone had managed to get those little cat's-eye swirls into the middle of the glass spheres. Curious still, he resorted to cracking them open — not an easy job. The method that worked, finally, was to heat the marbles in a frying pan and then dump them into a bucket of cold water. But it almost wasn't worth the trouble; those cat's-eye pieces that were so alluring when magnified through the clear glass were, in the end, disappointingly small.

Simpson's discovery at Shelburne Falls, though, spoke not only of the past, but of the future. Even though these marbles appeared to have been buried for the better part of a century, they were still in perfect condition. Once Simpson cleaned them off, they were as bright as the day they went missing from some turn-of-the-century child who was called inside for dinner. If Simpson had needed a sign that he had found the right place to make glassblowing his life, he now had it.

Soon he was blowing glass again, stretching his capabilities by tackling such demanding forms as wine goblets. His goblets, prized possessions for collectors, would become the mainstay of Simpson's works for a decade. Word of his talent spread, and within a month he was visited by a local high school teacher. Would he be willing, the teacher asked, to give a glassblowing demonstration for all the eighth graders in Franklin County? Simpson agreed, not realizing what he was getting into. For one thing, there were many more eighth graders in the county than he'd realized, enough to populate the studio each Wednesday for an entire semester. Furthermore, the students weren't exactly enthralled watching goblets being made. Each week Simpson tried to make his demonstration more interesting. Then, one Tuesday night, he hit on an idea that would have far-reaching effects.

The idea came to him when his thoughts turned to the experiences of the astronauts. On the Apollo 8 mission in December 1968, three men — Frank

Borman, Jim Lovell and Bill Anders—had made the first flight around the moon. Along the way they had seen Earth shrink to the size of a marble held at arm's length. At one point, Lovell realized that he could cover his home world by holding out his thumb. Anders compared Earth to a lovely and fragile Christmas-tree ornament. Simpson could vividly remember his own sense of awe at seeing these events unfold, and he knew the experience had been shared by everyone within earshot of a TV or radio. The moon flights were nothing less than a mountaintop experience for the human race: for the first time it sunk in for most humans that their world—so precious to everyone living on it—was just a speck compared to the vastness of the universe.

What if there were a way, Simpson thought, to share that realization with the eighth graders? He thought of marbles, like the ones he had dug up on his property. He would create marbles for them, but these marbles would be different; they would be miniature planets. Perhaps, Simpson thought, the kids would enjoy that more than a goblet. And perhaps they might experience just a bit of the Apollo adventure.

Simpson's idea turned out to be right on target. The glass planets were a hit with the kids. And in time, they became a solution to a problem Simpson was beginning to wrestle with about his own creative direction. He was becoming a commercial success; his works sold well, and he had a growing list of fans. But he wasn't satisfied.

In an effort to expand his repertoire beyond wine goblets and other conventional forms, Simpson turned for inspiration to the exquisite works of Louis Comfort Tiffany and, in particular, Tiffany's floral imagery in glass. Making glass flowers of his own within the walls of his vases and goblets would offer Simpson a new direction and a new challenge. But the glass flowers didn't solve his need for a more personal direction. "No matter what I did with the glass flowers," Simpson says, "everything I made looked just like Tiffany. I wasn't doing my own work. It wasn't my own voice."

That is where the planets came in. Already, an awareness of celestial realms had begun to creep into Simpson's work. Experimenting with adding

silver to his glass formula, he had come up with swirling patterns that he hoped would remind his customers of the night sky.

Now, with the glass planets, Simpson found an art form that melded his interests from childhood with his chosen profession. They let Simpson combine the awe he felt as a spectator to space exploration with the fascination he had for worlds in miniature, like the fish tanks that had so absorbed him as a kid. The planets also offered a way for Simpson to use techniques he had already mastered, such as those developed centuries earlier by Italian glassblowers, which he used in his glass flowers.

Today, almost three decades after he began blowing glass, Simpson makes planets as small as golf balls and as large as basketballs. He also continues to find new avenues of expression. He has created pieces he calls "New Mexico glass," designed to evoke the starry night skies of the American Southwest. "Tektites," another Simpson creation, take their name from an unusual type of meteorite made out of black, glassy material. And there are "portals," which combine the rough textures of his tektites with a polished window into what appears to be another universe.

And he is still learning, still honing his craft and finding inspiration in unlikely places. Once, at a cocktail party, he met a woman who worked for a German cosmetics company. What material, he asked, was used to produce copper-colored eye shadow? Rutile, came the answer, giving Simpson a new ingredient to use in his planets. After he sent some of the works to the German company, he learned that he had inspired them to establish a new division to make ceramic coloring agents. They now sell as much of these materials, Simpson says, as they do eye shadow.

Another inspiration came into Simpson's life in 1990, when — thanks to a wrong phone number — he met his future wife. Cady Coleman, a doctoral student at the University of Massachusetts at Amherst, called the Simpson

studio one evening, hoping to track down her friend Amy. Simpson, who often answers the phone after hours with an outlandish foreign accent, recognized Amy's name as belonging to a former employee. With a thick Eastern European accent, he told Cady how to reach her friend. Before saying goodbye, he asked Cady to convey his best wishes to Amy, and then had her practice saying his own fictitious and unpronounceable last name several times.

The conversation puzzled Cady — until Amy explained that the Eastern European gentleman was really Simpson, who had an unusual way of screening calls. At that point, Cady couldn't resist. She called back and informed Josh that she was a KGB agent: "We have reports of breaking glass, and your number is up." In the conversation that followed, Simpson invited her to visit the studio sometime. Cady might never have called again, but a couple of days later she mentioned Josh to a scientific glassblower at the University of Massachusetts, and described the wrong-number story. The glassblower told Cady, "You have to meet this guy," picked up the phone,

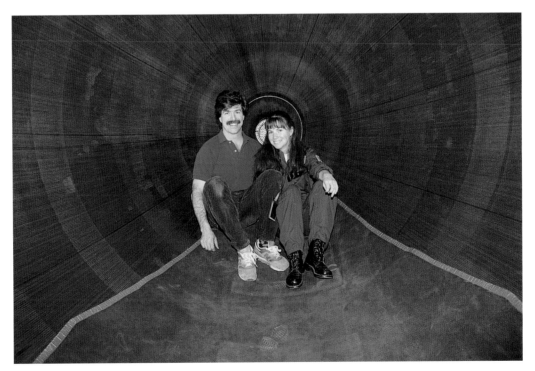

Josh and Cady inside the space shuttle main engine rocket nozzle, Kennedy Space Center, Florida.

dialed Simpson's number, and handed the phone to Cady. They met later that afternoon.

Two years later, Cady's life also took a turn toward the stars: NASA selected her as a Space Shuttle astronaut. When Cady made her first space flight in 1995, spending 16 days in Earth's orbit, one of Simpson's small planets went along for the trip. The couple was married in 1997.

While Cady spends most of her time in Houston, where NASA is located, Josh continues to live and work in Shelburne Falls. The 1802 farmhouse and barn have been transformed over the years. A fire in an old garage gave Josh a chance to expand the living area; it is now filled with glass and other objects he and his friends have made. The new garage contains one of his most prized possessions: a Pratt and Whitney Double Wasp radial aircraft engine. It is part of his collection of aviation-related stuff that can be found around the property. Simpson's "enchanted forest" behind the studio contains an experimental aircraft designed by Burt Rutan, the first person to fly nonstop around Earth.

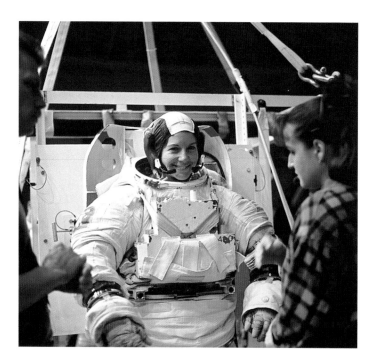

Cady in spacesuit.

Airplanes are not the only things Josh collects. He has cases filled with steel parts gathered from old equipment and machinery that he has rebuilt. Color bars for glass blowing line the hallway above the hot shop; they are as appealing as the shelves of an old-fashioned candy store. He has one of the most extensive private glass libraries in the country, which he tends with the same care and attention that he gives to the gardens in front of his house. Favorite volumes include *De Re Metallica* by Georgius Agricolae, published in 1556 — the first book ever to show drawings of a glass furnace — and *L'Arte*

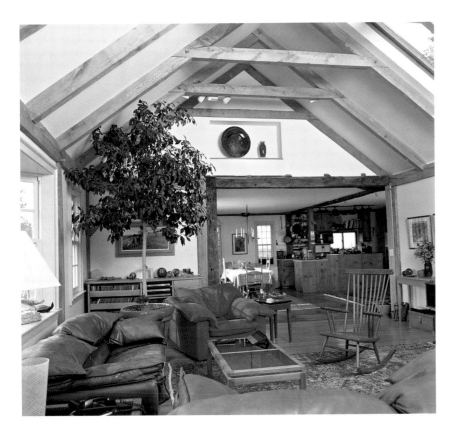

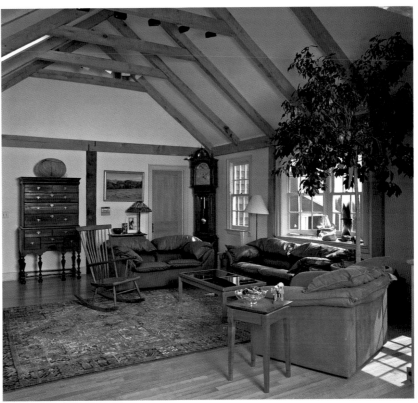

Simpson living room.

Enchanted forest behind the studio, with experimental aircraft in the background.

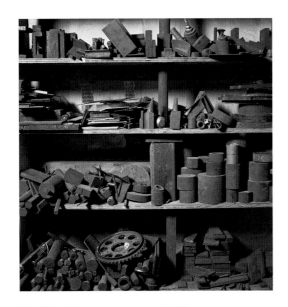

Small steel parts on storage shelf.

Vitraria by Antonio Neri, published in 1612. The shelves in his house are lined with curious and unusual objects that invite scrutiny and exploration — not surprisingly, the same feelings that his planets evoke. He doesn't deliberately collect anything other than books, but when pressed will admit it takes justs two objects to make a collection, and after that, it's hard to stop.

Being at his studio and his house is like being inside one of his megaworlds. There are beautiful views externally and internally; there are layers of material and information to sift through and digest,

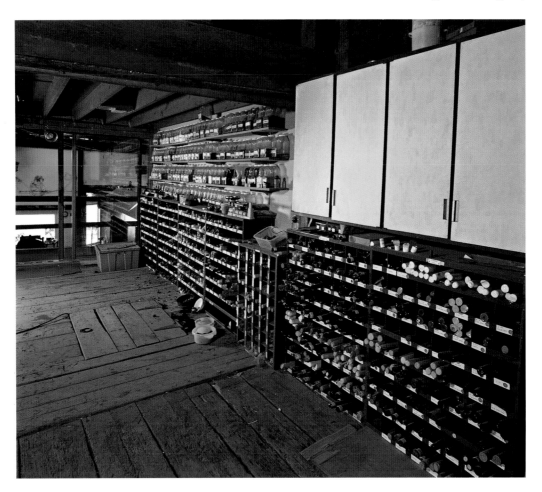

Color-rod storage shelves above the studio.

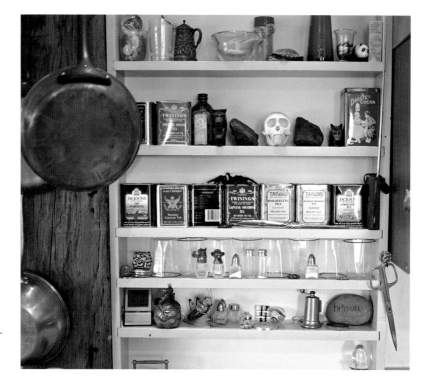

Shelves beside the stove in Simpson residence, with precious objects including iron meteorites and monkey skull.

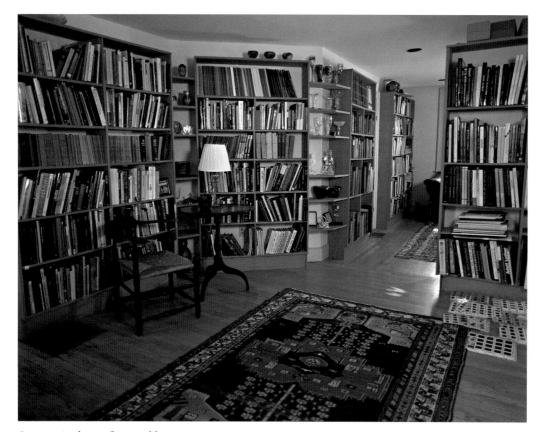

Simpson's glass-reference library.

Simpson with his Pratt & Whitney radial aircraft engine.

colors and textures and patterns swirling about like spaceships and bubble trails. As with his planets, the more you look around his home and his environment the more there is to see.

There are immense satisfactions to being a successful artist, to having your work shown in galleries and museums all over the world and even in the White House, as Josh Simpson has. But success alone would not satisfy him. For Simpson, creating works in glass has been a

Back door of hot shop and cold shop, with morning glories.

27

View of the studio in spring.

Front yard maple tree in autumn.

28

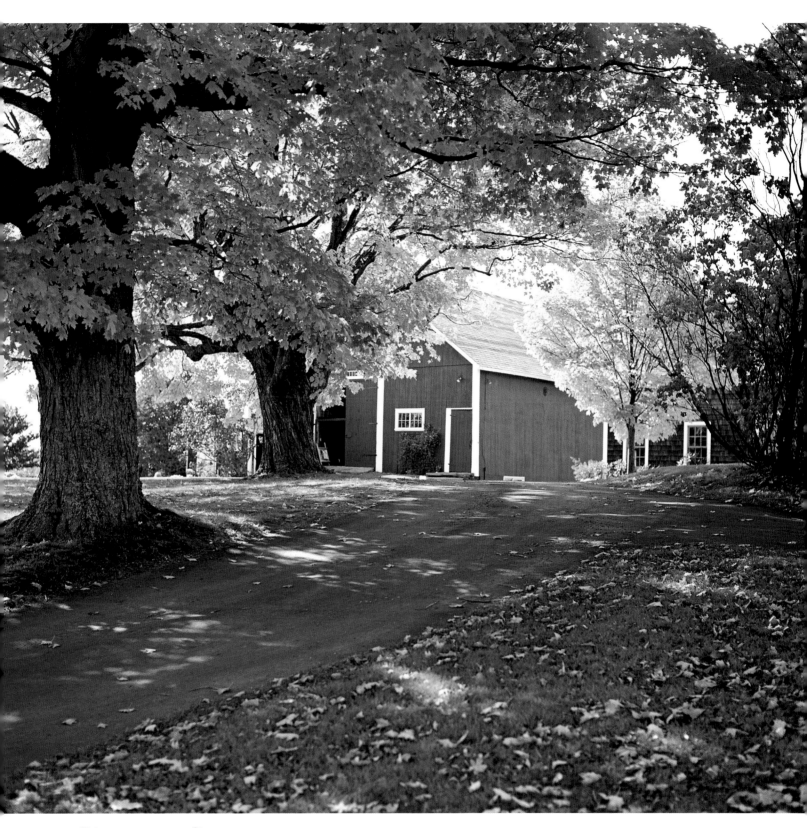

Driveway entrance to Simpson property.

means of communication, and he has always strived to reach the widest possible audience. Knowing full well that not everyone has access to the museums and galleries where his work is on display, that not everyone can afford to purchase one of his works, he hit upon an idea: he would give planets away.

The giving began at home, in the late 1970s, with Halloween goodies; when the local children stopped at the door, Simpson would give them each a planet along with some candy. The practice was such a hit that in the years that followed, kids from nearby and not-so-nearby towns started showing up. But Simpson's biggest satisfaction has come from something he calls the "Infinity Project." Simply put, Simpson — and his "agents" — are leaving planets all over Earth.

The idea goes back to that day in 1976 when Simpson found the marbles on his property. In a small way, those marbles had the same effect on Simpson as museum displays of glassworks from ancient Egypt: they transcended time. His planets, Simpson realized, will long outlive him. And so, long before he ever sold planets, he was hiding them. At first he chose flower boxes in his town. Then he began taking them along on trips and coming home without them. He has left planets in the catacombs of Paris, in the New York subways and at the base of the Golden Gate Bridge.

Some of the Infinity planets are hidden in easy places. Though, as Simpson says, "It's amazing how you can be in your surroundings and not see something right in front of your face." He has put planets on a city windowsill or next to a tree on a sidewalk and seen them sit there, day after day. But that's part of the fun for Simpson. "It's a secret that can be discovered," he says, "but it's not handed to you on a platter."

Because Simpson enjoys scuba diving and flying — he pilots a small airplane whenever time allows, and often rents a plane during vacations — he has also been able to deliver planets to some otherwise inaccessible locales, ranging from mountain lakes in Alaska to coral reefs in Belize to the Australian desert.

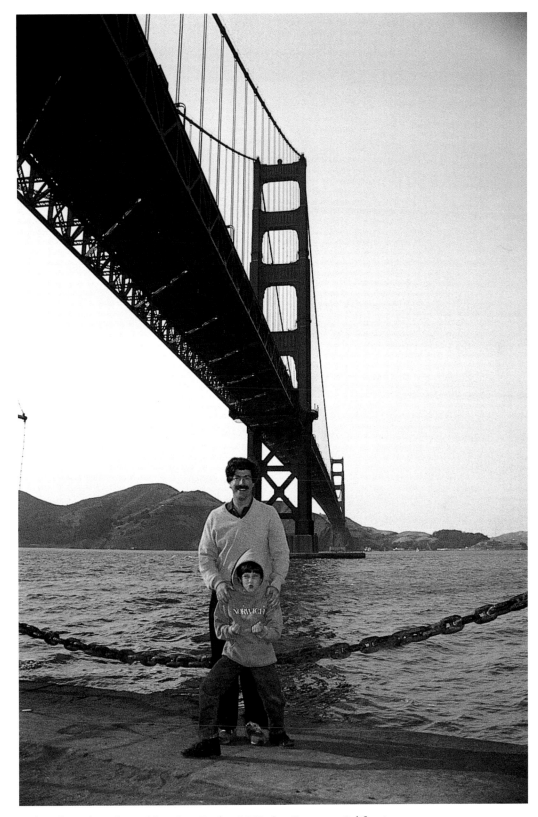

Josh and Josiah at the Golden Gate Bridge, 1989, San Francisco, California.

In recent years, he has opened the Infinity Project to the public. Anyone, anywhere, can send in an idea by mail or through Simpson's website, proposing a location where they would like to leave a planet. If Simpson likes the idea, he sends two planets: one to be left, and one for the person to keep. Requests are frequent and interesting; one Infinity planet was recently left in the zone patrolled by United Nations peacekeeping forces between Greek and Cypriot populations on Cypress.

Over the years, friends have pitched in and left planets in some even more remote places: on the floor of the deep ocean, courtesy of the famed Alvin submersible, and in the dry valleys of Antarctica (which scientists call the most Mars-like places on Earth). They're on Easter Island, and in Kazakhstan and Bali and New Zealand, and just about everyplace in between.

None of the Infinity planets are signed; they are an anonymous gift from Simpson to the world at large. He is amused at the notion that long after he is gone some archaeologist will come across one of the Infinity worlds and

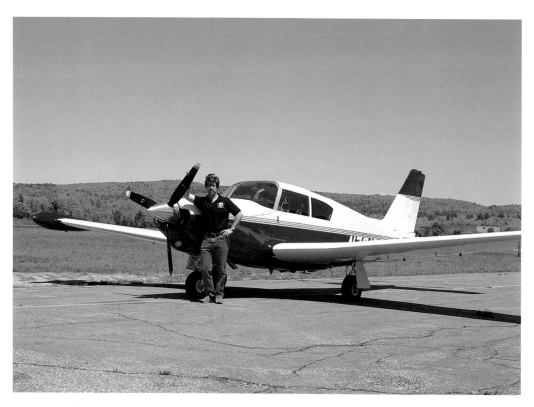

Simpson with Piper Comanche.

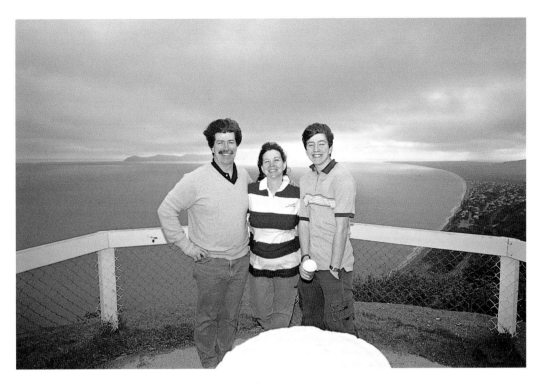

Josh, Cady and Josiah, Wellington, New Zealand, 2000.

wonder what it is and how it got there. The idea, says Simpson, is "to play a practical joke on the future."

To be sure, there is also the appeal of longevity. "Someday there will be thousands of planets around the world," he says. "I hope they will be found unchanged, and that people will be amazed and wonder what they were used for."

For Simpson, it's also a way of giving something back. "I've been extraordinarily lucky," he says. "I work pretty hard, but fortunately my work appeals to people. There are lots of artists I know who do beautiful work, but they also have to have a primary job that supports them. I'm so lucky that what I love to make are things people like to have in their homes."

It is still Simpson's greatest satisfaction and biggest thrill to learn what those people discover in his works. Their discoveries — so reminiscent of his own, whether looking into a tank of tropical fish or gazing up at a starry sky — are what it's all about.

STUDIO VISIT

THE MAKING OF A MEGAWORLD

The clouds have come down to earth in western Massachusetts, cloaking the town of Shelburne Falls in a late-winter mist. On days like these, Josh Simpson's studio can seem like a place apart from the rest of civilization, a universe unto itself. That impression isn't far wrong. It is here, in seemingly ordinary surroundings, that new worlds are being made.

Josh Simpson has been a glass artist for three decades. Since 1976, he has added to his extensive repertoire creations that he calls, simply, "planets." They began as oversized marbles intended to spark the interest of schoolchildren; soon they evolved into worlds in miniature. Today Simpson makes planets ranging in size from golf ball to basketball, and they are found, quite literally, in the far corners of the globe. You may encounter one in a store display window or a museum exhibition. Or you may stumble across one in a meadow in the

The studio in winter.

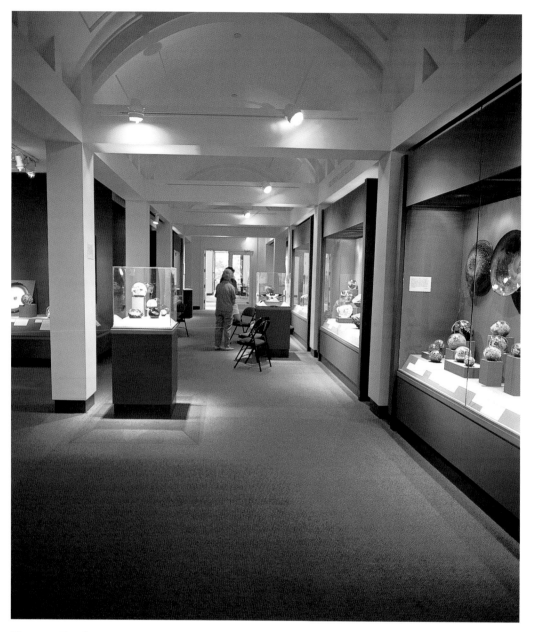

Visionary Landscapes, 1998, Bruce Museum, Greenwich, Connecticut.

Scottish highlands or in the deserts of Egypt. Simpson's planets reside in the ice fields of Antarctica and at the bottom of the deep ocean.

Wherever you find one of Simpson's worlds, you will be arrested by wonder. Walking past one of his planets is out of the question; there is no alternative but to stop for a long, detailed look. Staring into its transparent

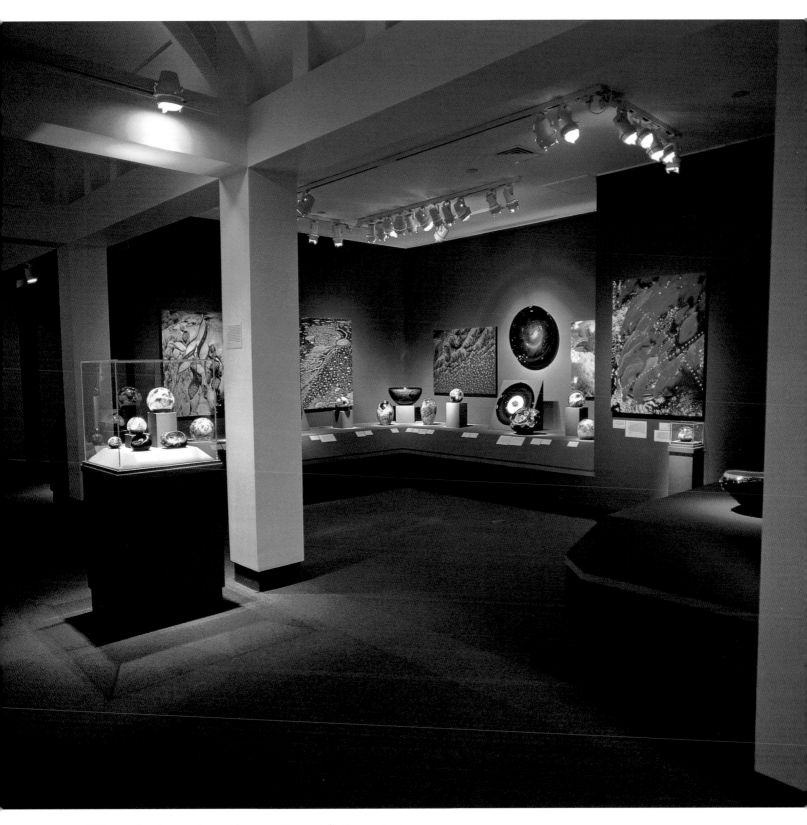

Visionary Landscapes, Bruce Museum, Greenwich, Connecticut.

Planet beside a volcanic vent at the bottom of the Atlantic Ocean, near the Azores.
Woods Hole Oceanographic Institution photo.

depths, studying the play of color and form, you can't help wondering how on Earth it came to be—if it really did come into being on Earth, and not somewhere else.

The reality is that Josh Simpson's planets, like his other works in glass, are born in a collection of 19th-century farm buildings on a hill overlooking the town of Shelburne Falls. Simpson has lived and worked here since 1976. This is where he has honed his craft, one world at a time.

EARLY MORNING

It's about 8:30 a.m. when Simpson calls together his team of assistants to plan the morning's work. Today, they will make a "megaplanet," a basketball-

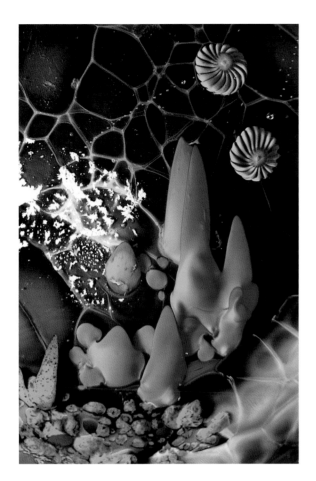 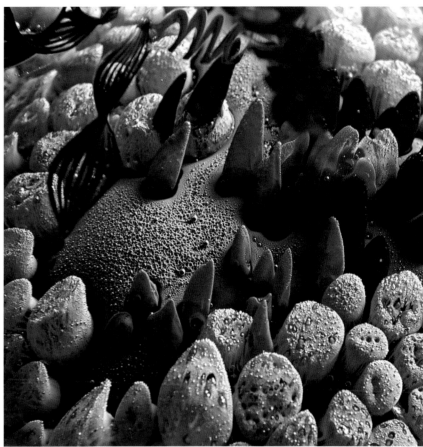

sized world that is the most extraordinary—and the most difficult to pro-
duce—of Simpson's planets. In part, the difficulty comes from their sheer
bulk, for a completed megaplanet can measure as much as 13 inches in diam-
eter and weigh 75 pounds. Then too, the larger worlds are vastly more com-
plicated than their smaller counterparts. Simpson puts so much more detail
into his megaplanets—more layers of glass, more subtleties, more varieties
of materials—that he usually tackles the job of making them only once or
twice a year. This is one of those rare days when a megaplanet will be born.

■ ■ ■

Preparations are underway in the converted barn that has become the main studio, the "hot shop." Stepping inside, where there is no trace of winter chill, a visitor is surrounded by half a dozen furnaces, some of which have been in continuous operation for years. The average temperature inside them is more than 2,000 degrees Fahrenheit. When the door is opened even slightly, there is an assault of heat and light: the instinctive reaction is to back away. Yet this is where Simpson and his assistants will work for the next many hours.

The dangers of the work are impossible to miss. Earlier in the week, a crucible inside one of the furnaces cracked, spilling 350 pounds of molten glass

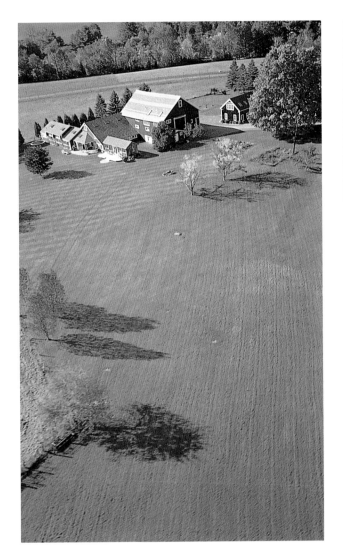

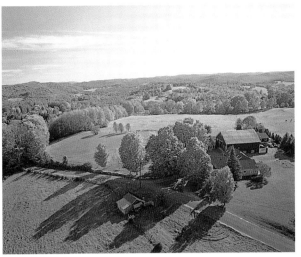

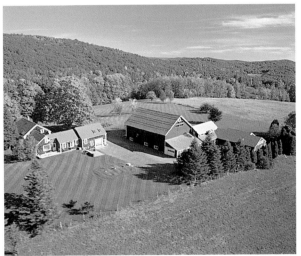

through the doorway and onto the floor of the studio. Simpson walked into the studio to find the glowing mass spreading across the concrete floor like a volcanic eruption. It had already devoured the rubber wheels of the furnace, taking them down to bare metal. Careful to avoid being scalded, he raced to pour water on the spill, arresting its motion and avoiding further damage. A scorch mark remains where the uppermost layer of concrete was vaporized.

There are 125 pounds of glass inside another furnace; this will be enough for today's megaworld.

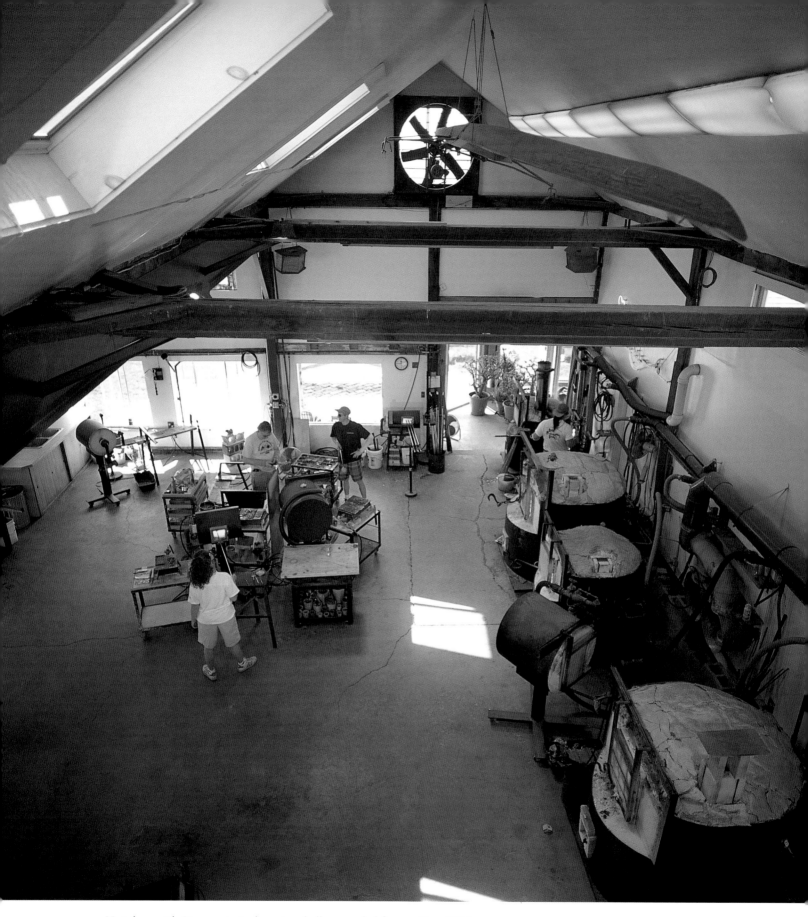

Hot shop with Simpson's single racing shell suspended from ceiling, 1999.

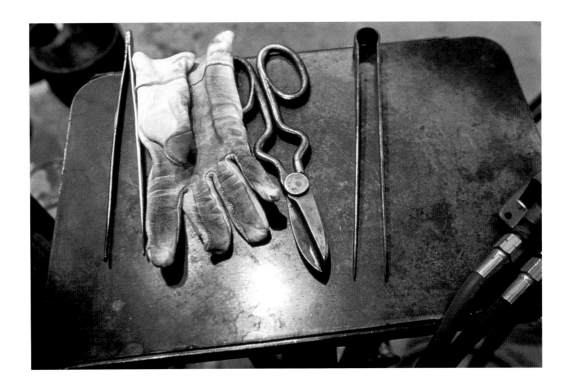

Glass is as demanding as it is beautiful. Placed inside the furnace, 125 pounds of glass will melt in about 20 minutes. It takes an hour for the glass to reach 2,400 degrees, at which point it has the consistency of warm honey. It is crucial to let the molten material stay this hot long enough for bubbles to rise to the surface and disappear; otherwise, flaws in the glass will ruin the finished piece. After an hour, the temperature is slowly reduced to around 2,100 degrees, where it will remain until Simpson begins working.

Simpson knows that the recent spill is just one of a hundred things that can go wrong, and already have. When a megaplanet is complete, it must spend a long time—up to two months—inside a computer-controlled kiln while it cools, sometimes by fractions of a degree per hour, to room temperature. Any faster and the glass would shatter. Once, during a power failure, a slew of worlds was destroyed while Simpson stood by helplessly; there was nothing he could do to save them. After that, Simpson installed a backup power system.

Another time, when the kiln was opened, a crack was discovered inside a finished planet. Eight weeks earlier, Simpson had worn Kevlar gloves as he placed the still-incandescent globe in the kiln; now he realized the gloves, at a temperature of about 80 degrees, had been cold enough to cause a portion of the glass to contract too rapidly, creating a tiny flaw that later spread. He soon came up with an effective, if somewhat nerve-wracking, solution: Simpson holds up his gloved hands and has a coworker spray them with the flame of a propane torch for a few moments before he picks up an infant world.

Over the years, Simpson has learned to approach his work with the mindset of a high-performance jet pilot: things go wrong, and when they do, there is no point in panicking; the only way to handle the situation is to consider the possible solutions—very quickly—and act.

Despite all the precautions, though, Simpson understands that there are no guarantees, that at the end of two months, when the kiln is opened, he may discover his work was all for naught. He is philosophical. Glass is such a temperamental substance, Simpson says, that it seems to have its own ideas about whether his efforts should succeed. He knows that he can do his part in the creation of a new planet, but that ultimately, it's up to the glass.

MID-MORNING

By 10 a.m. the hot shop is alive with activity. There is almost always music playing when Simpson and his team are at work. A selection is chosen to be invigorating but not distracting. It can be a Celtic instrumental with a contained wildness reflecting the room's mixture of methodical artistry and primeval forces. Or it can be the Bulgarian Women's Choir, or classic rock. On this day, a Bach concerto blares from a tape player, but it must compete with the sound of the blowers that supply the furnaces with air, a continuous jet-engine rumble that can be felt as much as heard.

For Simpson, this is a time of preparation. Already, he has envisioned the many steps he and his assistants will make in creating this particular mega-world; now he must get ready to carry them out. He inspects the placement of

materials selected for the new planet, which are now arrayed on tables around the studio like trays of penny candy. He has chosen them not only for their aesthetic merits but also for their physical characteristics. For example, the metal oxides that give the glass color also change its rate of expansion, and thus its behavior during cooling. Within a megaworld there are a slew of these dissimilar materials; how Simpson combines them could mean the difference between success and failure. Even after nearly a quarter-century of making planets, each new world is a kind of starting point for Simpson, and a kind of test.

While Simpson makes final preparations for the creation of the megaplanet, one of his assistants, Rick Bardwell, begins work on a smaller world. This planet, just a few inches across, will become a kind of buried treasure: it will sit within the finished megaworld, visible only through the flat, clear surface at the larger planet's base. Most people who acquire one of the heavy giant planets never see the underside, and so never discover the existence of this little inner world. Simpson likes the chance to keep a secret, even from his audience.

The first gather.

The creation of the inner world begins as Bardwell approaches the opening to the glass furnace, wielding a five-foot metal blowpipe. Dipping the end of the blowpipe into the crucible of molten glass, he picks up a glowing mass. He moves a short distance from the furnace, where he shapes the blob into a sphere using, remarkably, a wooden form. It's made out of a block of fruitwood whose surface has been carved to a concave shape. After creating these shaping tools—the wood sometimes comes from downed trees on the property—Simpson and his assistants submerge them in a tub of water until they are thoroughly waterlogged. Some of the shaping tools, which are used for only moments at a time, have spent most of the past decade under water.

Simpson rolling crushed glass on the planet surface to form continents.

As Bardwell applies the shaping tool to the glass, the wood smokes but does not burn. Then he returns to the furnace to add more glass, and this new surface must be shaped. With each application of molten glass, called a "gather," the sphere grows in size. The work is time-consuming and exacting, but it does not require Simpson's direct participation; he has already briefed Bardwell about the inner world's ultimate size and appearance. For now, the clear glass ball Bardwell has made, slightly bigger than a softball, is merely a starting point, a canvas on which Simpson will create the surface of the new world.

The materials Simpson will use for the world's "continents" await nearby. There are crushed glass filaments no thicker than a human hair. There are strips of special optical glass that create a subtle, colorful play of light. There are clear glass slugs containing hairlike, colored filaments; they look as if they've been sliced from some kind of silica candy cane. And there is something that is a key to the planets' ethereal beauty: powdered silver. Exposed to intense heat, the

seemingly bland whitish powder turns an inky blue, like the sky in the outer fringes of Earth's atmosphere, at the edge of space.

The blowpipe is now in Simpson's grip. Quickly, before the glowing world can cool more than slightly, Simpson dips it into the piles of glassy fragments and powders until it is crusted with raw materials. He dares not let the planet touch the materials for more than an instant; if it does, the glass might also pick up the metal plate on which the materials sit. Prying the plate from the sticky, viscous glass without ruining the planet would not be easy.

A transformation is at hand. Simpson sweeps the brilliant flame of an oxy-acetylene torch across the glass and silver. The torch blossoms, bathing Simpson in its yellow-white glow. Within the searing flame, powders fuse and mix, combining and changing color. Continents are born.

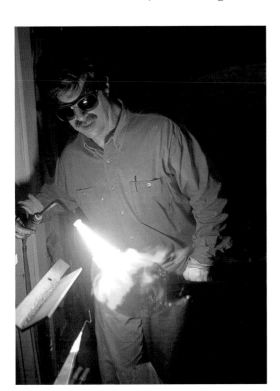

Simpson heating the planet surface with an oxy-acetylene torch.

Now the continents receive finishing touches. Simpson uses the torch to blast a small area, creating a "meteorite crater" on a newly formed continent. Then he adds pieces of gold leaf, applied with tweezers to the scorched glass surface. The thin gold will stand out brilliantly against the swirling patterns of white, yellow, gray and deep blue when the planet is cool.

Right now, however, Simpson can only imagine those vivid patterns. The colors of the globe's surface are pale, bathed in the incandescent planet's orange glow. It is one of the challenges of the craft that he must see the new world not only as it is, but as it will be. In the fleeting moments in which he can work the fiercely hot glass surface, Simpson strives to create vistas on which the eye can feast. Often he departs from his carefully conceived plans to take advantage

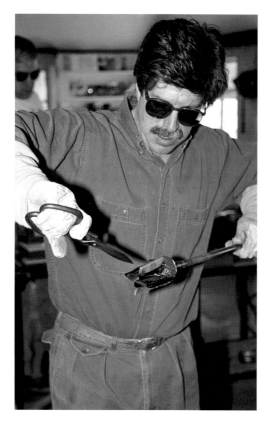
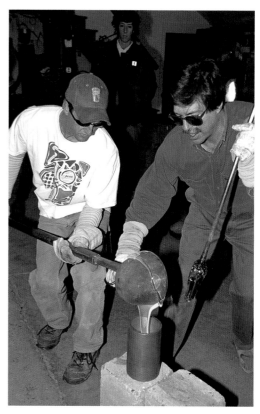

Making spaceship cane (clockwise from top left): shaping wings with shears; filling a cylindrical mold with crystal to surround colored wings; shaping a cylindrical gather; the first stretch.

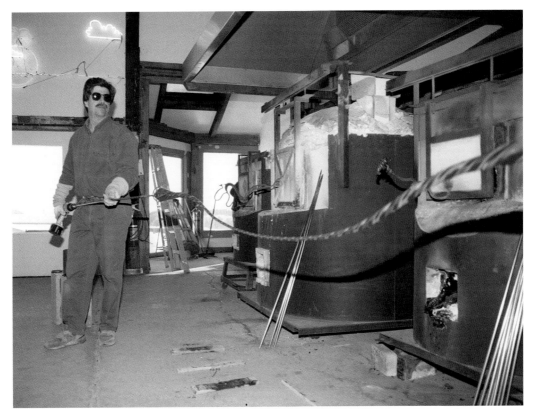

Continuing to pull and twist; shaping cane into spaceships; bowl of spaceship cane.

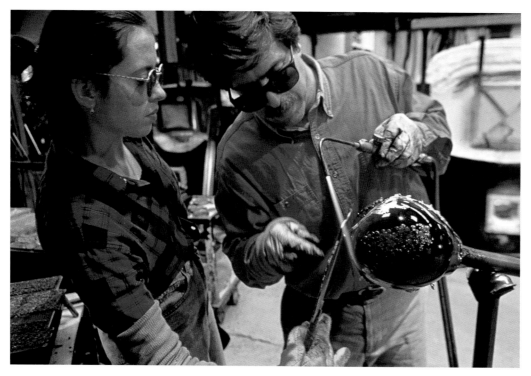

Adding cane to create cities on the planet's surface, with Margaret Langdell.

of the particular shapes and forms developing on the surface. Sometimes he uses an altered dentist's drill to etch fine lines in the molten glass to draw the viewer's eye to an interesting area. In such moments he is thinking as much like a painter as a glass artist.

Now Simpson creates the megaplanet's outer realms. First, another clear layer of glass is added. Then comes the placement of what Simpson calls "space-ships": tiny, intricate beads of glass cane that, when covered by more glass, will appear to be suspended in orbit above the planet's surface. The spaceships exemplify, as much as anything, the reason Simpson says it takes "about two hours and 20 years" to make a planet. He means it, not only because he brings more than two decades of glassblowing experience to each new work, but because he created some of the components going into the new planet that long ago.

Next to one of the beads, Simpson attaches a strand of platinum wire—it comes from the manufacturing of pacemakers—that will serve as the spaceship's trail. Another gather and then, after an hour's work, the inner world is finished.

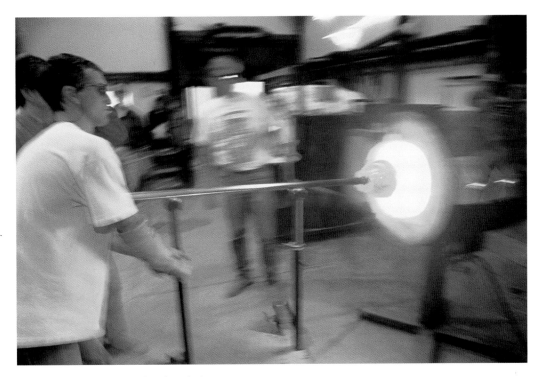
Reheating the planet in the glory hole.

But this is just the start of the megaplanet. The newly made inner world goes into the furnace, where it is all but swallowed by a fresh gather. Emerging, the glowing mass of molten silica is as viscous as molasses, and Simpson must use tweezers to pull the newest layer around the core so that it completely envelops the inner world.

As the work progresses, the relaxed anticipation that filled the studio earlier in the morning gives way to a mounting tension. The making of a mega-world involves a very long series of small moves. Any one of them, done wrong, could ruin the work. Everyone knows that with each new step, the investment of time and energy increases, and with it, the risk of failure. They also know there is no turning back; once they begin, they must see this emerging mega-world through to completion. The growing sphere of molten glass offers no alternative.

Now there are half a dozen people gathered in the hot shop, and what happens next is a carefully choreographed sequence of moves, with each

assistant playing a key role as Simpson forms the continents and atmosphere of the megaworld. To keep the glass from distorting under its own weight, two or three assistants must continuously turn the blowpipe, no matter how much their arms and wrists begin to ache. If they stop rotating the sphere for a moment—necessary while Simpson dips it into a pile of crushed glass or places a spaceship—they must quickly flip it 180 degrees to let the force of gravity act evenly on the slowly flowing mass. This also allows Simpson a few more precious seconds in which to work before they begin turning again.

For Simpson, the process of forming the megaplanet's surface is just the same as for the small, inner planet—except that now the weight of the growing sphere is becoming a serious difficulty. It's a simple matter of physics. With the planet—now upwards of 50 pounds—at the end of the five-foot blowpipe, it is all Simpson can do to lift it. If he places his hands a safe distance from the scorching mass, he can't get enough leverage. And so he moves in closer, so close that if he lingers more than a few seconds his Kevlar gloves will begin to smoke. If that happens, the worst thing anyone can do is to

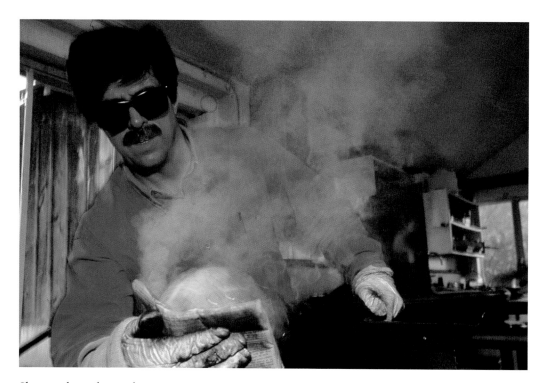

Shaping the gather with wet newspaper.

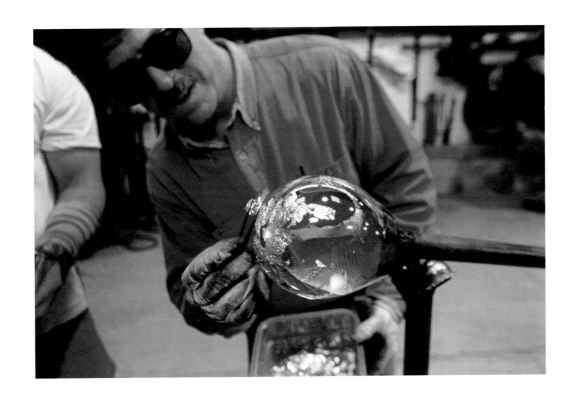

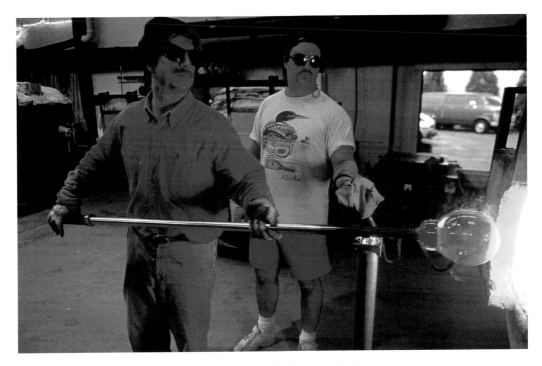

Adding gold and platinum foil to the inner core and reheating the planet.

throw water on him; the resulting cloud of steam could scald him. Instead, Simpson pulls the gloves off and drops them. If that means dropping the planet, he will do it; saving his work is not worth being badly burned.

That, Simpson says, is something that has never happened to him while working with glass—in fact, he says, he has been more seriously burned in his own kitchen from the splatter of bacon grease. He is extremely careful. Experience has taught him to check the fingers of his gloves for bare spots before using them; he also wears sunglasses or even a reflective visor to protect against the intense heat, which can damage eyesight. As the megaworld grows in size, an assistant is assigned to shield him from its heat with a thick wooden paddle. Even with these protections, however, Simpson can spend only moments working on the planet's surface, grimacing against the searing heat. In those instants, with the struggle written on his face, Simpson has entered a territory less familiar to artists than firefighters.

Now everything moves quickly. Moments of assembly work with glass strips or spaceships or gold leaf are interspersed with trips back and forth to the glory hole to reheat the piece. There is no conversation, save for brief, coded exchanges:

> "Heat for five seconds...."
> "Switch direction...."
> "OK, you hold the door...."

Murphy's law strikes: a torch fails to light when Simpson needs it, and his assistants discover that a tank of oxygen is empty. Simpson knows the mistake will affect his planned design slightly, though he won't know how until the planet is cooled. At any rate, there is no time to dwell on the error; the planet won't wait.

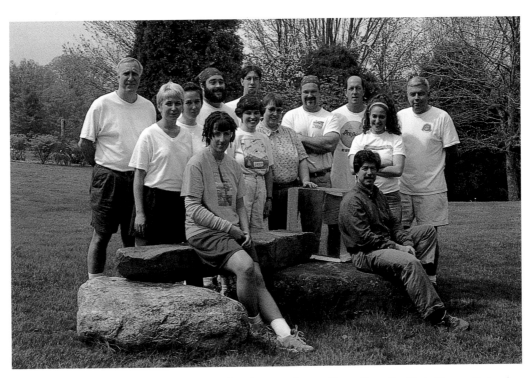

Studio crew, 2000. Left to right: Ned Dibble, Christina Emery, Diane Porcella, Katie Brown (intern), Alex Brezinski, Deb Levin, Kyle Shea, Diantha Wholey, Chad Sarafin, Jay LaRocque, Simpson, Deb Adler and Rick Bardwell.

There are more steps now to create the complex surface, each as irrevocable as the stroke of a calligrapher's brush. Due to the planet's weight, each step becomes a feat of athletic grace. Simpson's wife, Cady, once likened the scene to football players dancing ballet. Simpson likes the image; it reminds him of the deceptive simplicity apparent in the movements of both the best ballet dancers and the best football players. "If you watch ballet," he says, "it looks *so* effortless, and you believe you could do that, you could actually stand up on your toes—until the moment you actually try it."

With each gather the planet seems to double in weight; it is so big now that Simpson cannot hoist it with the blowpipe. Instead, he stands on a specially made three-wheeled cart, resting the blowpipe on a metal support. In this way

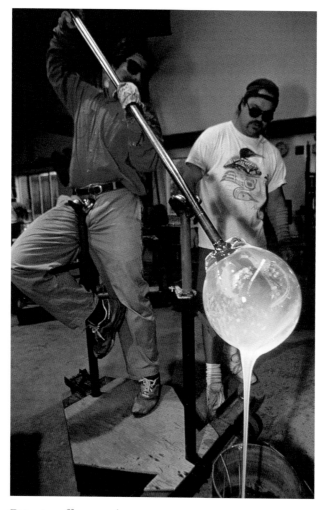

Dripping off excess glass.

he can still lower the planet into the crucible to gather more glass or apply its surface to a plate of glass fragments. This is the strangest sight of the morning: as his crew pushes Simpson and the planet to the furnace for another gather, back to the worktables, and to the furnace once more, it looks like some kind of alien vehicle.

By this time Simpson and his assistants are nearing the limits of what they can physically do. Simpson musters reserves of energy and strength to continue working the glass. If he has neglected to drink enough water during the morning, he will also be dehydrated and begin to feel sick. He knows he can't think about it, any more than a ballet dancer can dwell on fatigue during a performance.

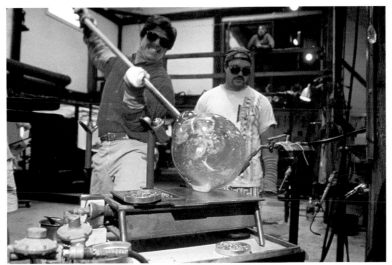

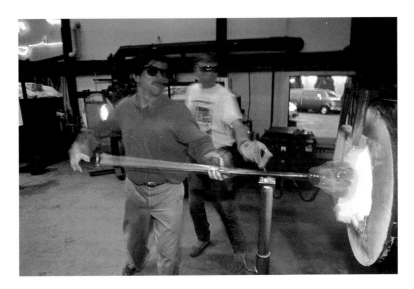

Adding spaceships and satellites to the upper atmosphere.

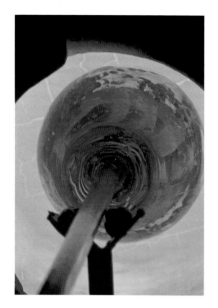

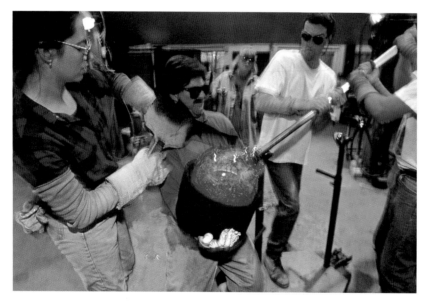
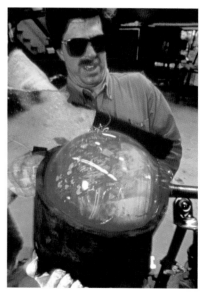

Clockwise from top left: heating in the glory hole; Simpson with Chad Sarafin; using a carved wood block to shape the planet. Simpson and his assistants make all the furnaces and equipment used in the studio.

More trips back and forth to the glory hole and the furnace. Simpson adds another gather, then a layer of spaceships, then a second layer of ships, and a third. In the background, a Beethoven symphony provides the soundtrack to the primordial spectacle. Simpson will say later that as he works he no longer senses the passage of time. He is unaware of the tool he has in his hand, or of the physical objects around him. There is only the megaplanet taking shape before him.

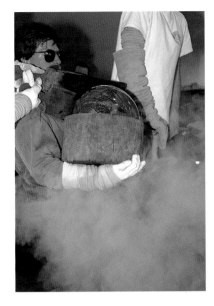
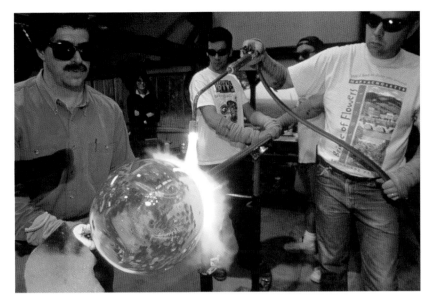
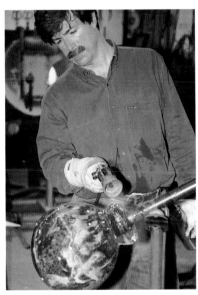
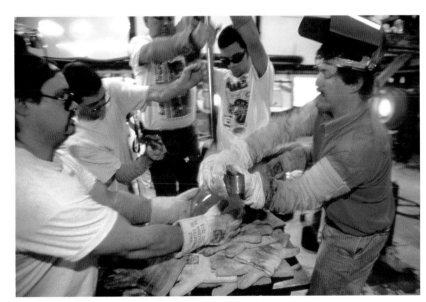

Final steps: (top left) steam shoots from the bottom of the block as the megaworld is shaped; (top right) shaping the bottom of the megaworld prior to separating it; (bottom left) a propane torch is used to even out the temperature and prevent cracking; (bottom right) breaking the megaworld off the blowpipe.

NOON

Only a few more gathers now—there will be about 15 when all is done—and the megaworld will be finished. Emerging from the glory hole, it is stunningly beautiful, glowing in pastel shades of red and yellow, spinning as Simpson's assistants turn the blowpipe. In this moment it could almost be a real world, with a

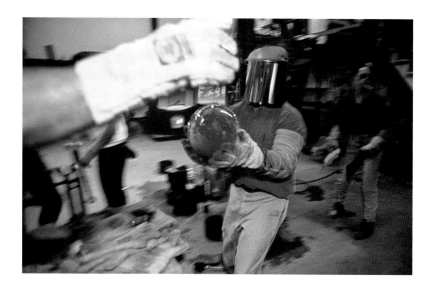

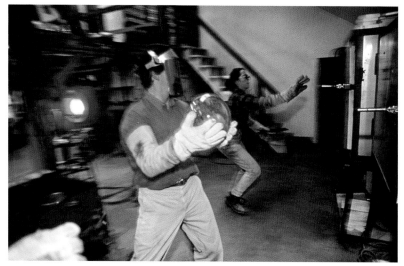

Simpson carrying
the megaworld to
the annealing oven
where it will be
cooled for the next
40 days. Rick Bard-
well holds onto his
belt as a safety
precaution.

real world's promise of life and even civilization. Simpson can only imagine what it will look like, weeks from now, when it is cool. He will be the one to open the kiln door, the first to find out whether his work has produced a failed attempt that will never leave the studio—for there is always that possibility—or an object of wonder, destined to stop countless viewers in their tracks.

"Every single day," Simpson says, "there are pieces that fail my expectations." Sometimes it's a technical failure that ruins a piece; in those cases there is nothing difficult about the decision to put it in the reject pile, destined for destruction. Other times the failure is aesthetic, and in those cases Simpson has learned to give the piece some leeway. Sometimes, a year later, he can take another look and realize that he no longer remembers what his original goals for the piece were and that it looks just fine. He'll say to himself, "That's a nice piece," and designate it to join his other works out in the world.

Often enough, though, that first glimpse into the kiln will bring relief and even joy, as he gazes on the new world. He will thrill to the sight of it and to the moment when he can reach out with his bare hand and, for the first time, touch the smooth, hard surface.

But now, with the megaworld cooling slowly in the kiln, he can do no more. From this moment on, it is up to the glass.

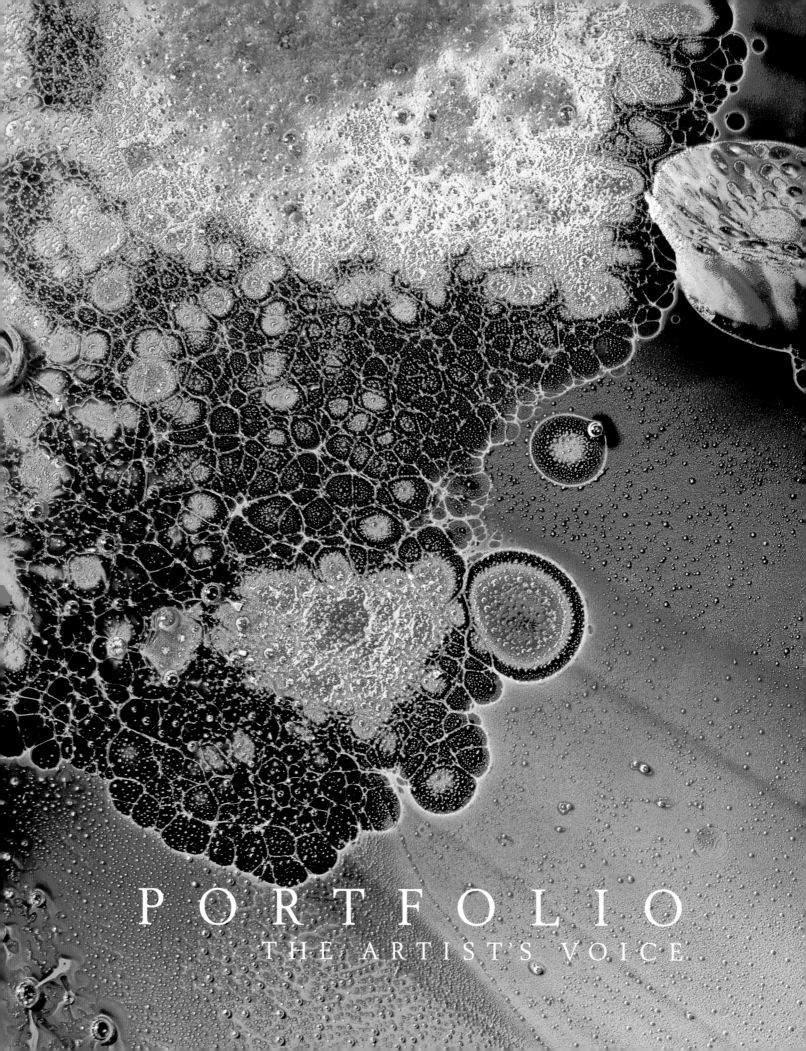

PORTFOLIO
THE ARTIST'S VOICE.

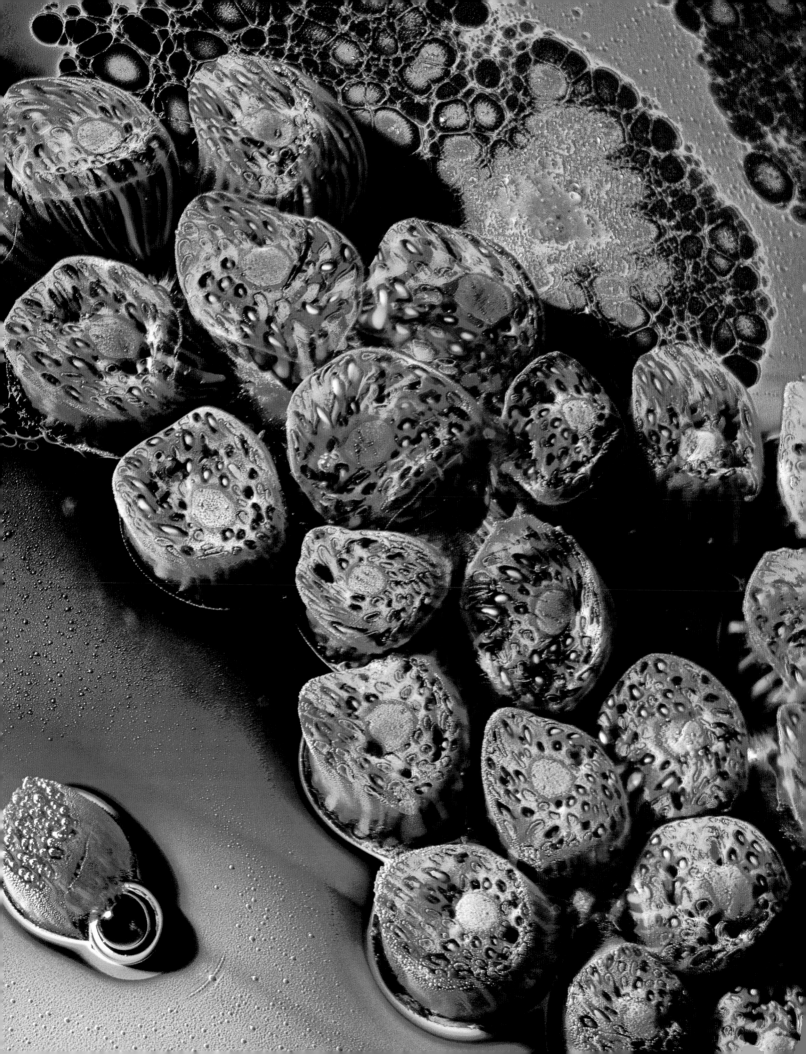

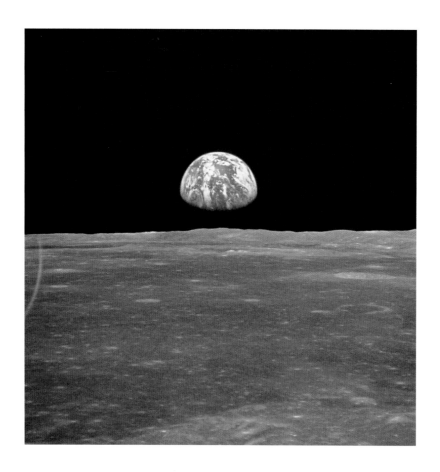

"I think of glass an alchemic blend of sand and metallic oxides combined with extraordinary, blinding heat. The result is a material that flows and drips like honey. When it's hot, glass is alive, moving gracefully and inexorably in response to gravity and centrifugal force. It possesses an inner light and transcendent radiant heat that make it simultaneously one of the most frustrating—and one of the most rewarding—materials to work with.

I began to make planets in 1976, when I agreed to have all the eighth graders in the county visit my studio for glassblowing demonstrations. I learned after the first week that making wine goblets and other traditional forms did not interest them at all. Marbles, however, were something they could relate to. Cat's-eyes, swirls and trapped air bubbles fascinated them.

PRECEDING PAGE: *Megaplanet* (detail).
ABOVE: Earthrise over the moon. NASA photo.

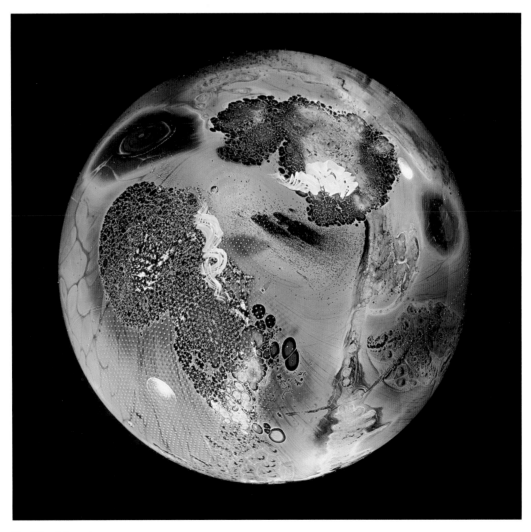

Big Blue Megaplanet.

Jim Lovell, the Apollo astronaut, remarked that he could cover Earth with his thumb as he looked out the window of his spacecraft. Of course, from 60,000 miles away, our world looks like a child's marble — a perfect blue sphere suspended in the black void of space. I realized that I could show techniques of glassblowing and at the same time say something to the eighth graders about our world and the universe by making little planets, the size of marbles.

The first planets I made were not complex. They were round cores with bits of colored glass on the surface. Eventually I started adding little pieces of millefiori left over from my floral vases. Because they appeared to float or orbit over the core of the planet, I made up stories to entertain the kids about the possibility that the planets were inhabited. I was my own Captain James T. Kirk, with my crew of eighth graders debating whether a planet had enough oxygen to support life forms. Pieces without spaceships became "possibly inhabited" planets, but a planet with a spaceship or bubble trail was surely inhabited. This distinction allowed me to vary the complexity of pieces. For years I didn't sell planets; I made them only during demonstrations or as gifts for visiting children. I still give them out on Halloween.

When I think about my planets, I go back to those early marbles; in some ways those tiny objects are the quintessential expression for me. If I had to pick one piece to give to someone special, it would be my simplest, smallest planet."

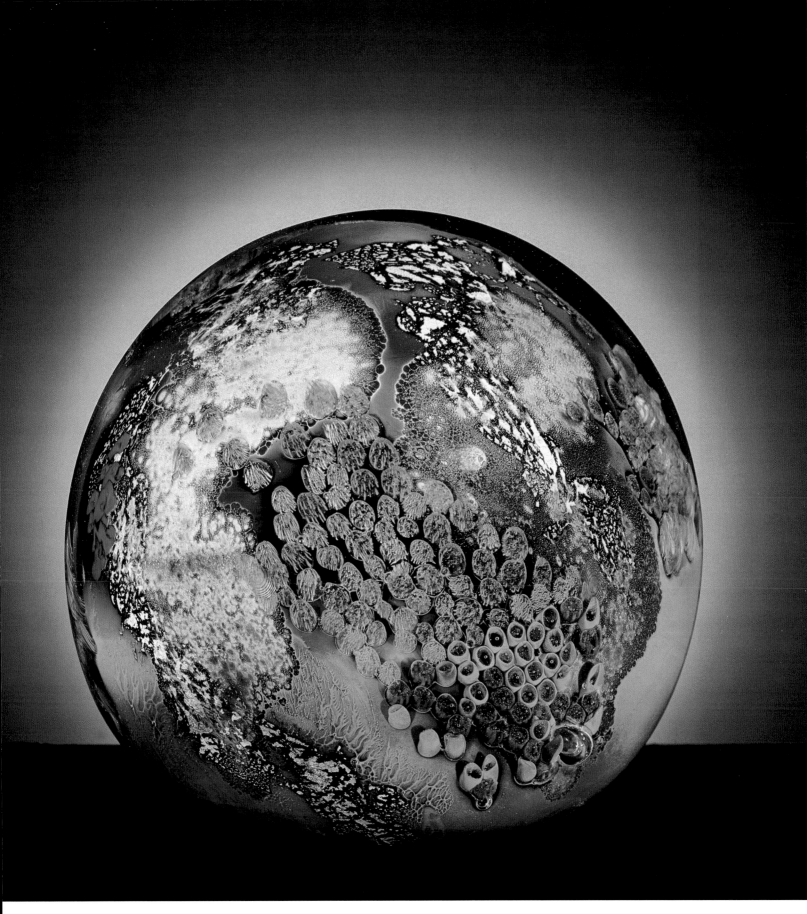

Megaplanet.

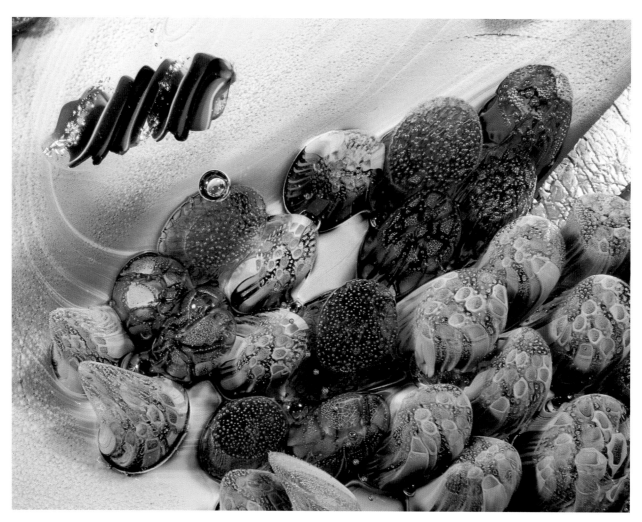

Planet detail.

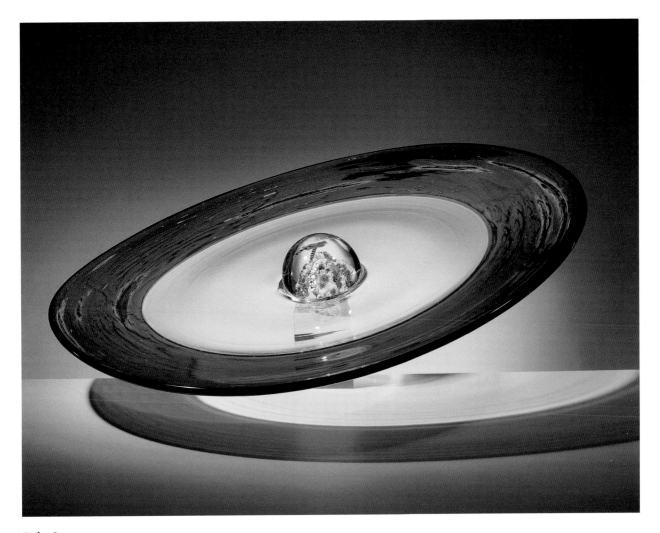

Ruby Saturn.

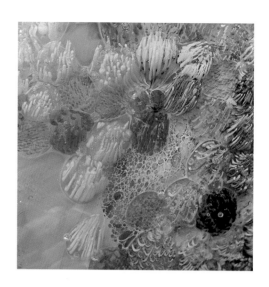

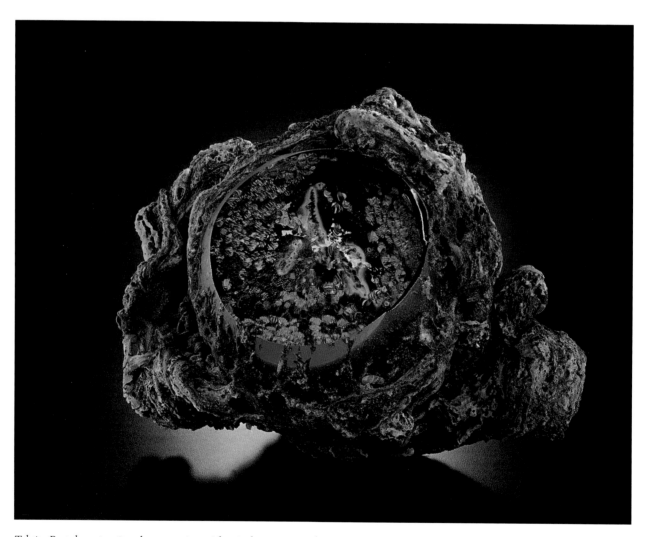

Tektite Portal, meteorite glass exterior with window into an alternative universe.

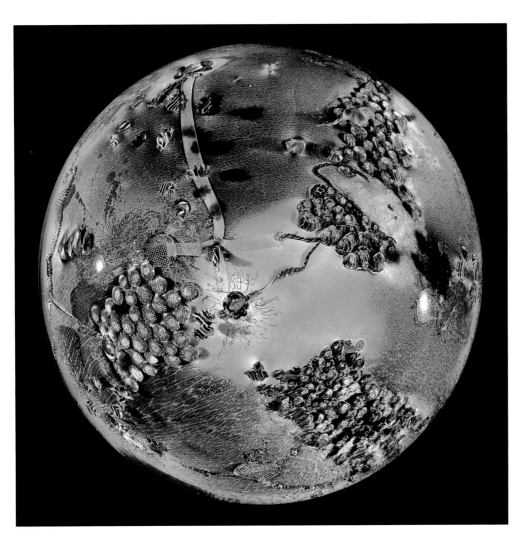

Megaplanet, collection of Brunnier Museum, 12" diameter, 73 pounds.

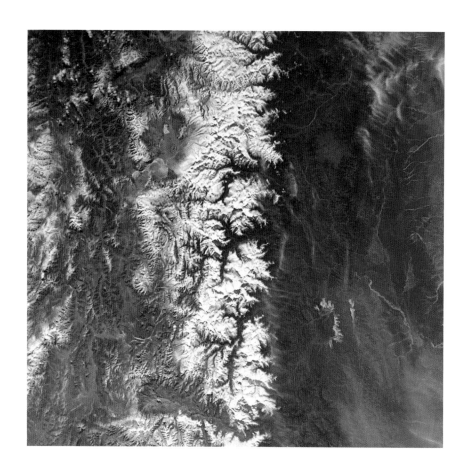

"I always wanted to fly. When I was a kid, I did everything I could to get a bird's-eye view of the world. I'd climb trees, telephone poles or anything else I could find. I would even sneak out the upstairs bathroom window of my parents' home; from there I could scramble to the top of the roof where I had a superb view of the neighborhood. It was my wife—who had long had her pilot's license—who encouraged me to pursue and achieve what had been an impossible dream of learning to fly. From an airplane, you can explore the world and get a different perspective on your surroundings. Scuba diving is very similar to flying. With both you find yourself looking out a window at an amazing landscape below. The ultimate, of course, would be to look at Earth from the space shuttle."

Mountains on Earth. NASA photo.

Mountain ridges on *Megaplanet*.

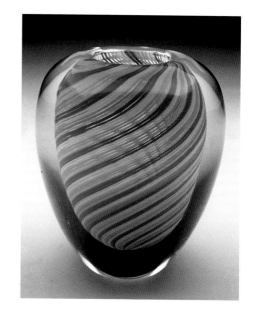

"Shelburne used to have the most beautiful dump in New England. It was located most of the way up a steep hillside with an incredible view down the valley. On Saturday mornings I'd load up my truck with a couple of trash cans filled with everything including the glasswork that didn't measure up to my standards that week. Some weeks I'd return home with stuff that others had discarded that I thought I might make some use of. It never occurred to me that someone might find my rejected glass attractive.

My first one-person show was in an Upper East Side gallery in New York. I stayed the night before the opening at a friend's apartment. As we walked to dinner down 14th Street, I noticed some intriguing glass in the front window of one of the antique stores. The pieces were the same as my own — same colors, shapes and designs. The next day, on the way up to my gallery, I stopped at the antique shop and asked to see one of the pieces. A moment later the telltale flowers typical of my work at that time made me realize that it was indeed mine. The owner of the shop told me that the vase was made by Tiffany and that it and the others had been in the collection of an old and reputable New England family. The irony was that the unsigned work I had tossed out was now being sold for more money than the signed pieces I had uptown."

Thick Latticino Vase.

New Mexico Platter with white spiral galaxy.

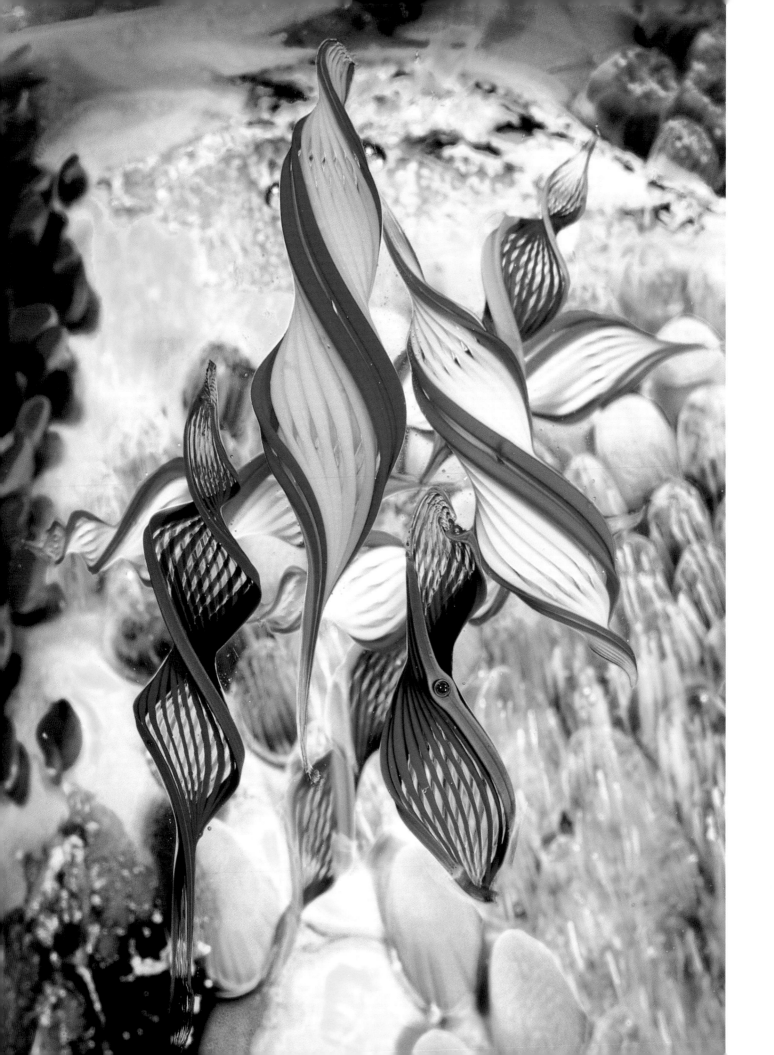

Spaceships ready to be deployed.

Latticino spaceships in *Megaplanet*.

Flower vase with filament cane representing pistils and stamen.

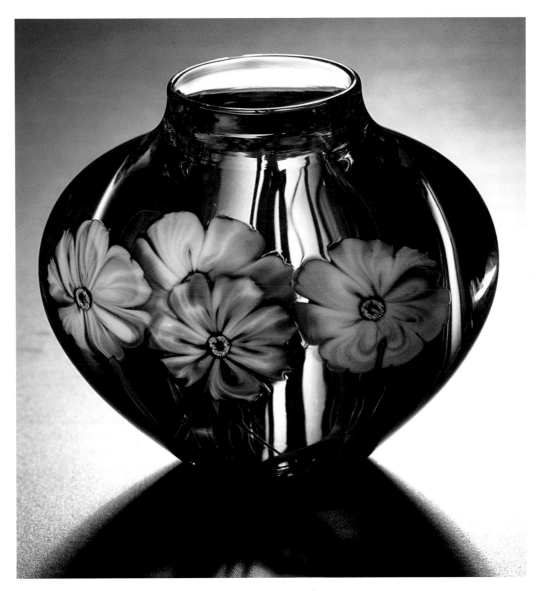

Flower vase. This early work led to more complex cane making.

"I thought everyone would share my enthusiasm for glass if they could only see it being formed — molten, glowing and alive — on the end of a blowpipe. I built a furnace and a cooling oven on the back of an old boat trailer and wound up demonstrating glassblowing at schools, museums, nature centers or any other place that would have me. I was certain that people would be compelled to buy my work if they were only able to watch how demanding it was to make. The sales part turned out to be more difficult than I imagined. I took my glass road show to the American Crafts Council Rhinebeck Craft Fair in 1973, but I didn't sell anything as a result of my demonstration. It took less than eight minutes to make a delicate thin-stemmed goblet in front of the audience — I made it look so easy that nobody was willing to pay the eight dollars I was charging for each at the time. Sales improved dramatically when I accidentally left the goblet in the furnace for a moment too long. The delicate drinking vessel turned to an unrecognizable lump in a heartbeat and made people realize that they were not so easy to create after all."

Early glasswork with two "perfectly matched" ruby wine goblets, 1972.

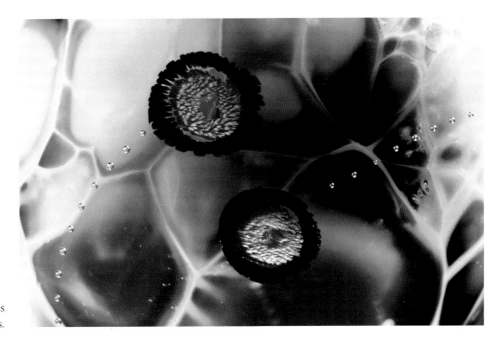

Filament cane used as spaceships.

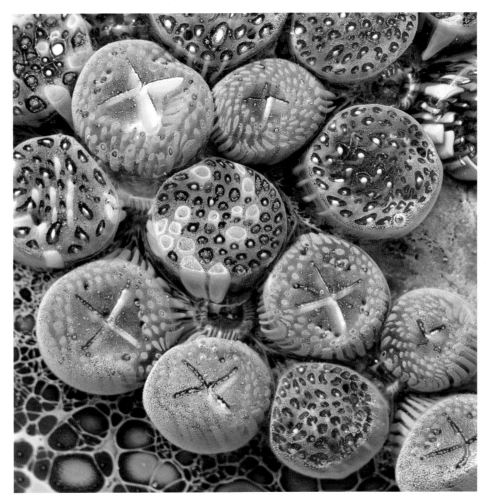

Megaplanet surface (detail).

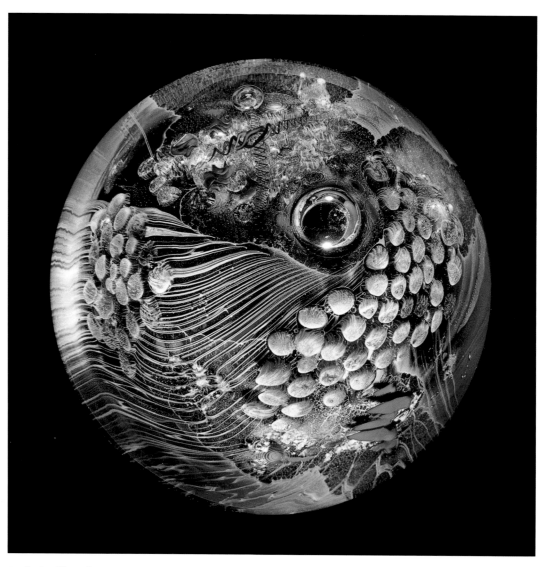

Little World, 3" diameter.

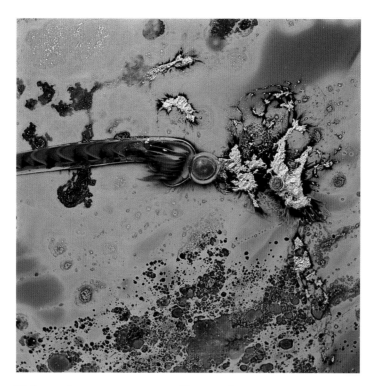

High-speed transport system on *Planet* surface.

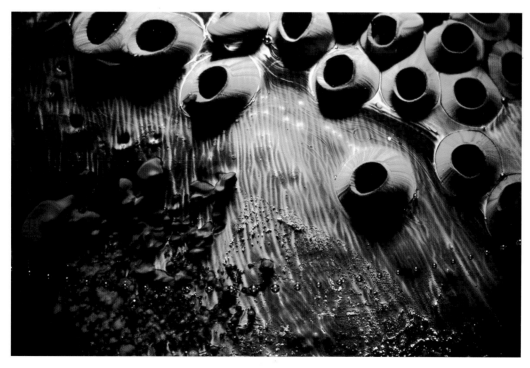

Extinct volcanoes.

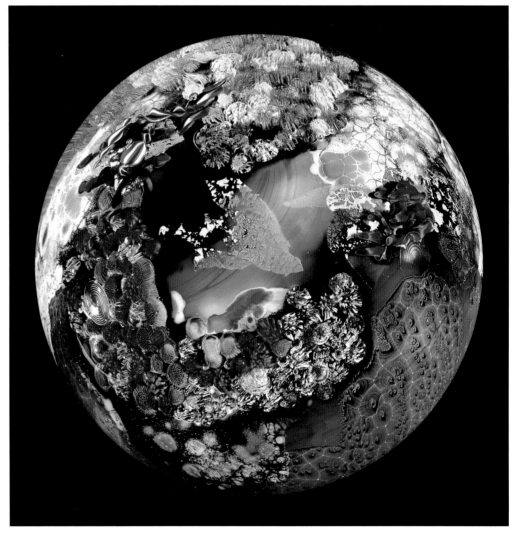

Megaplanet.

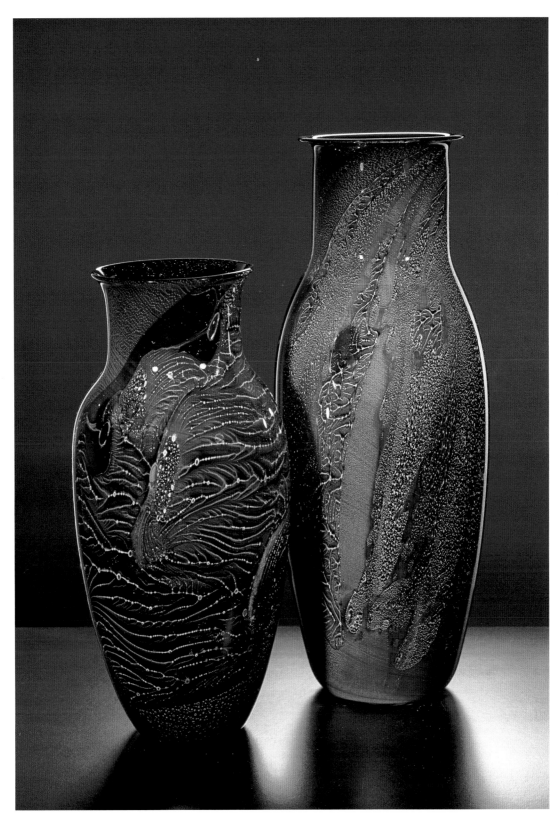

New Mexico Vases.

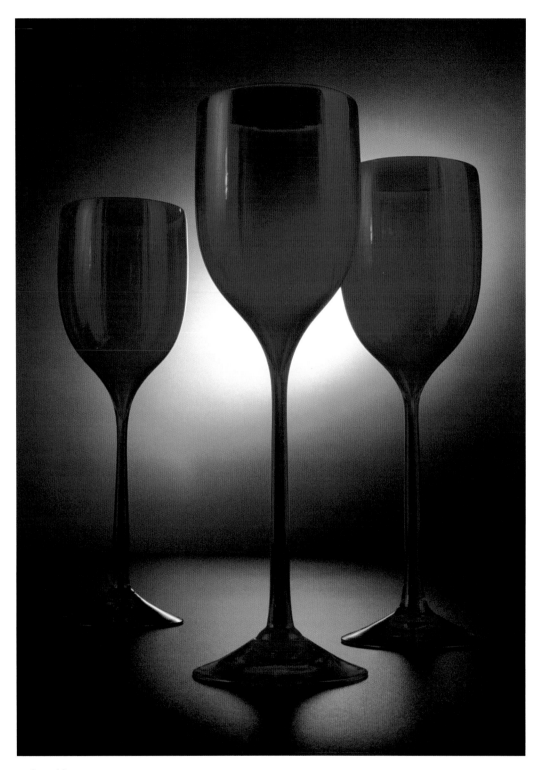

Ruby goblets.

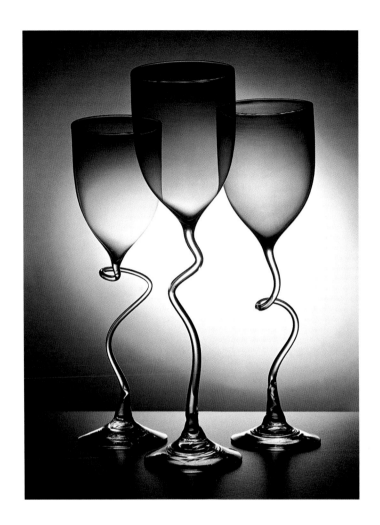

"The last thing I do at night before I go to bed is walk out to my studio to check the furnaces. Accompanied by my cat and occasionally my son Josiah, I can watch thunderstorms develop down the valley, see the aurora borealis or just watch the sky on a clear winter night.

I moved to Shelburne Falls in 1976 — to the cheapest house with the biggest barn I could find. The part of the barn that became the hot shop had been used to raise ducks and was filled up to the four-foot windowsills with duck manure. It took two of us four days to empty the studio of all signs of its previous occupants. We used the manure to fertilize a vegetable garden that

Twist-Stem Goblets.

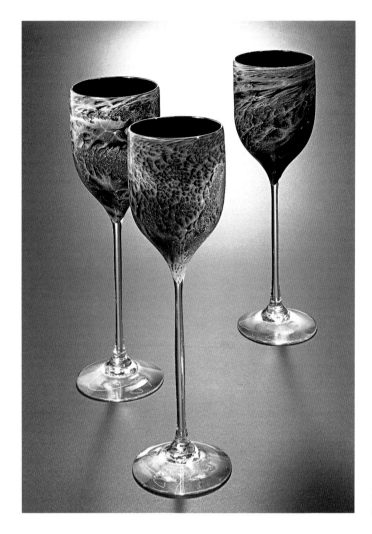

New Mexico Goblets, collection
of Corning Museum.

yielded amazing produce for the next decade, including a stand of asparagus
that has flourished for 23 years.

My home is an 1802 New England farmhouse with typical post-and-
beam construction. I purchased the property from blacksmith Nol Putnam.
The first day we looked at it, Nol called me into the house. Knowing I was a
glass blower, he asked me if I knew the person who made two goblets he had
on a kitchen shelf. They were mine. When we moved in, Nol and I traded a set
of six more goblets for a candle chandelier that still hangs above my dining
table.

I made goblets for 17 years, and in that whole time I made only a few
that I considered perfect."

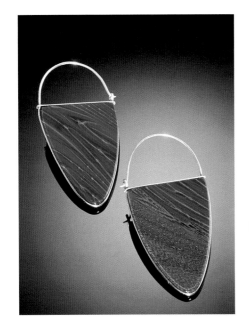

"I was given permission to tour and photograph nuclear power plants as an artist. One of the most profoundly fascinating things I witnessed was Cherenkov radiation, which appears as an incredibly pure blue light emitted from uranium fuel rods glowing below 40 feet of crystal clear water in the core of a reactor. I resolved to somehow re-create that intense blue color in my glass.

Making glass is kind of like making bread—there are an infinite number of recipes. Slight variations in proportions, temperature and cooking times will yield radically different effects. In the early 1980s, through an arrangement with the Brockton Art Museum, I had an opportunity to experiment with glass formulas. Every week for a year I mixed a new batch of glass varying the concentration of some of the basic coloring elements such as silver, gold, cobalt, tin, manganese or potassium dichromate. If I came up with something that looked interesting, I would make small changes to push the formula. It was an alchemic process aided by a little bit of luck and by my evolving knowledge about the properties of glass.

Within a year, I had refined my recipe for what I call "New Mexico glass." The color was close to the blue glow of Cherenkov radiation; it also reminded me of the sky on a perfect summer night. I had never been to New Mexico at the time, but that was how I imagined the color. The patterning sometimes looks like the ocean during a storm, with swirling waters and crashing waves. At other times, I can make it look like a satellite photo taken of our Earth from space."

New Mexico Earrings, created in collaboration with Carla Caruso.

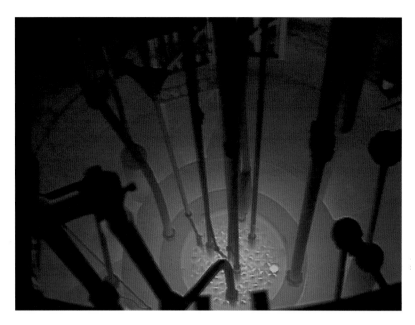

Cherenkov radiation inside a nuclear reactor.
Nuclear Regulatory Commission photo.

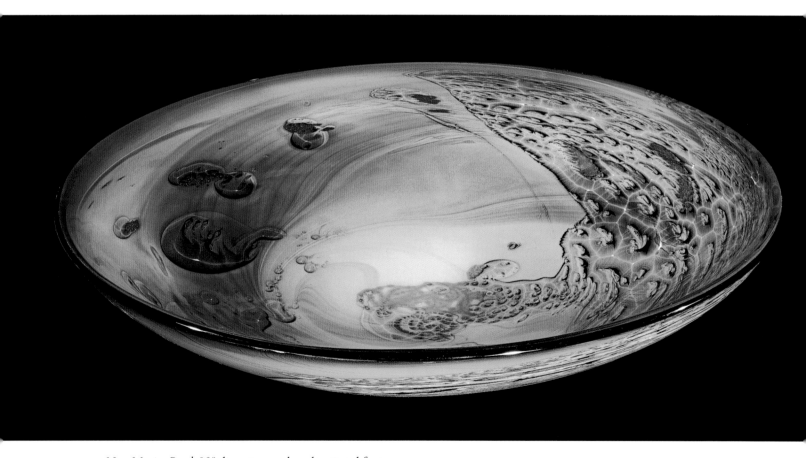

New Mexico Bowl, 19" diameter, made as baptismal font.

"A friend gave me some incredibly fine platinum wire. His laser welding company used it as the electrode wire in the heart pacemakers they constructed. The wire was perfect for me to use to represent an intergalactic communications antenna on the surface of a planet."

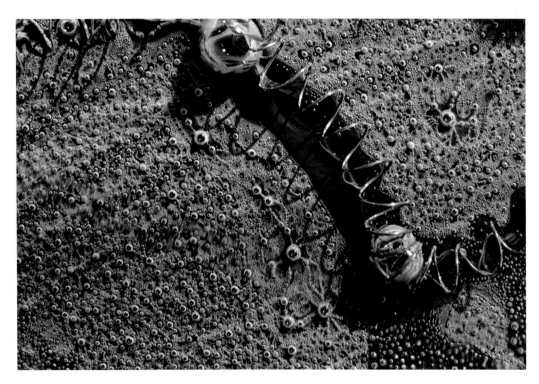

Intergalactic low-frequency communications antenna.

Namibian desert. NASA photo.

Alluvial river valley, *Megaplanet.*

Domed cities, *Megaplanet.*

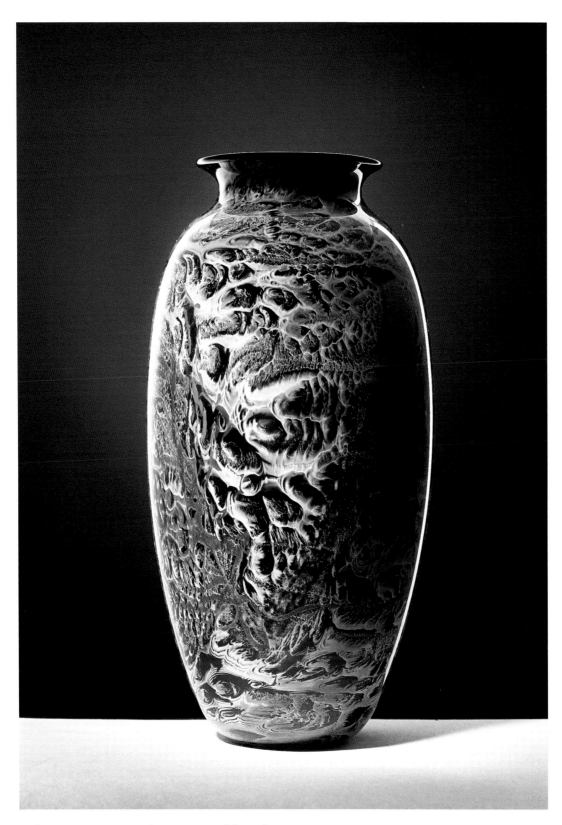

Red *New Mexico Vase*, early experimental formula.

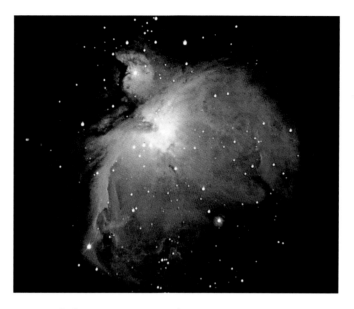

Great Nebula in Orion. NASA photo.

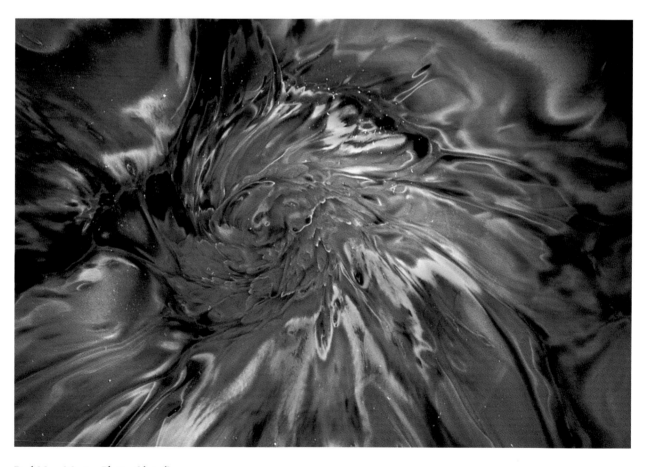

Red *New Mexico Platter* (detail).

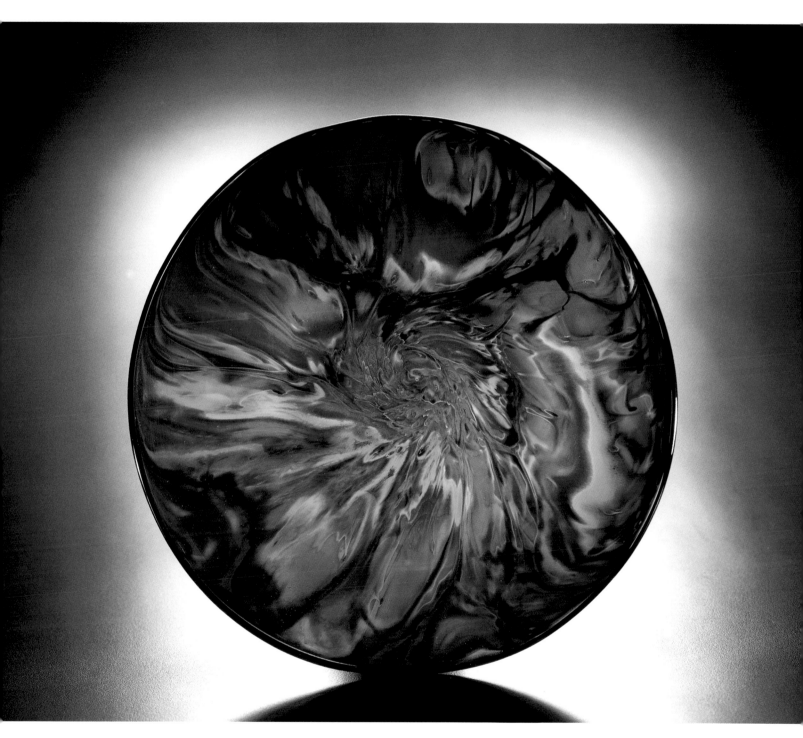

Red *New Mexico Platter.*

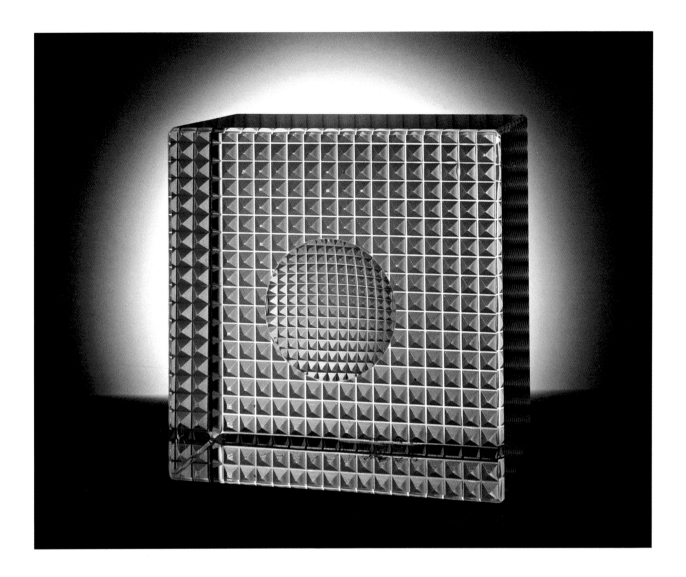

"Probably the worst thing I ever agreed to do was make 350 pressed medallions to commemorate the 50th anniversary of a mental hospital. I was desperate for cash, and being paid a dollar apiece for making something so simple seemed like an easy way to make money. They also wanted me to drill a small hole through 100 of the medallions so they could be hung in a window or worn as jewelry. For those I was to be paid an extra 30 cents each. The fact that I had never attempted to press glass or that there might be technical hurtles to overcome never crossed my mind. I was transfixed with imagining how beautiful

Laser Optic #2, optical glass cast into carved graphite mold.

96

these objects would be. It also seemed like having them finished in time for the celebration ceremony in three weeks wouldn't be a problem.

I knew that graphite was soft and could be carved, and that it was also capable of withstanding the intense heat of the molten glass. Once I found a supply of what is essentially pencil lead, I began to experiment cutting and carving letters. The material is a pain to work with, and within a few minutes I was covered with dusty black powder. Early on I realized that the letters and design had to be cut backward—just as with a printing press—so that they would be correctly oriented when pressed into a gather of molten glass. After spending more than a day carving the design, I poured a small amount of molten glass out on a steel table and carefully pressed my mold into it. Everything seemed fine until I tried to separate the glass from the graphite. Because there were undercuts in my letters, the glass became permanently stuck to the face of the mold. That's how the first two molds I attempted were ruined. The third worked better, but it took every moment of the next three weeks and 1,100 medallions to learn how dramatically glass temperature, color density, rate of cooling time and pressing force affect the success of the piece being made. All this before I even attempted to drill a "simple" hole so they could hang.

An experiment that seems to end up going nowhere can lead to something more interesting. Years later, I made a series of cast sculptures—"laser optics"—using similar graphite molds.

Whenever I'm asked about the relationship between art and science, I think about my mental hospital medallions and reply—without doubt—that you could never have one without the other."

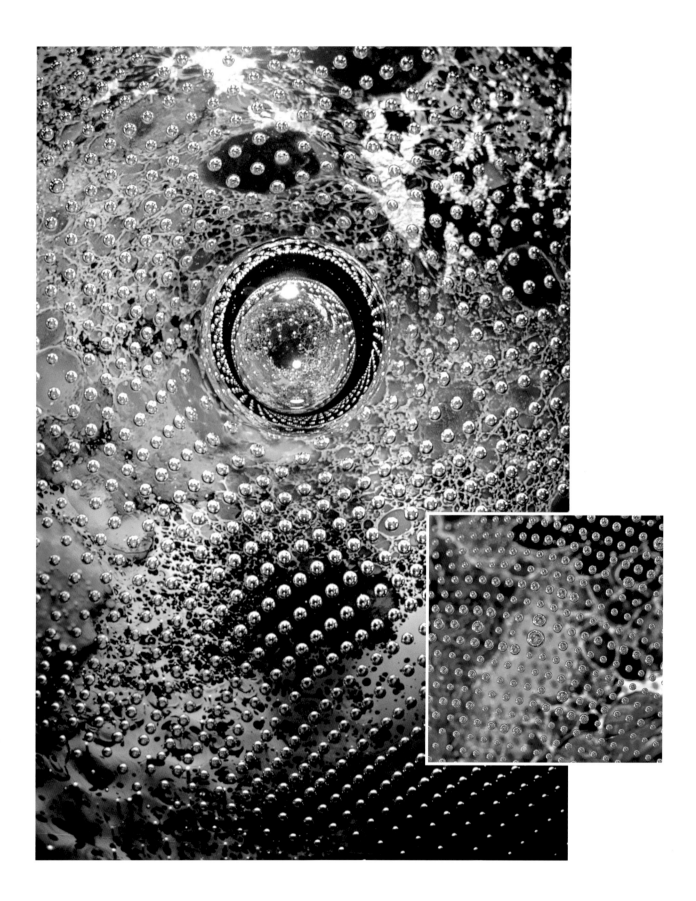

98

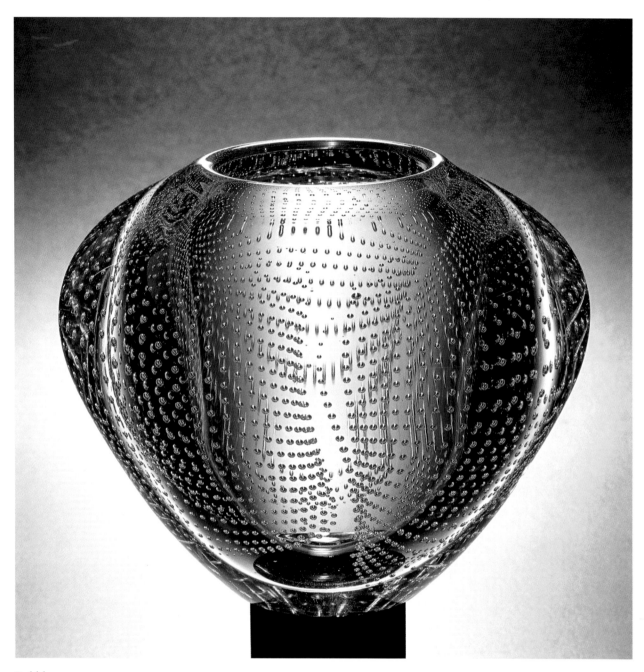

Bubble vase.

Star Wars defense network and
geo-synchronous communica-
tions satellite network (detail).

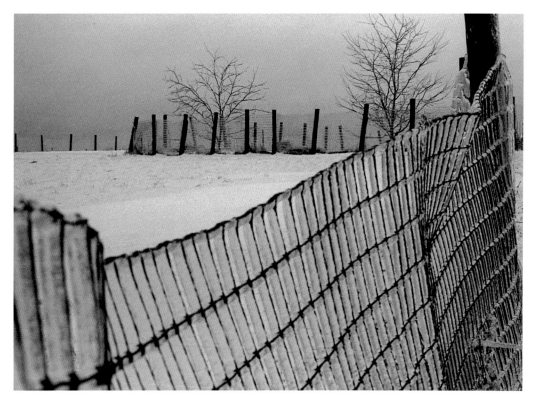

Ice fence around Simpson sheep pasture, Shelburne Falls.

Close-up of fence.

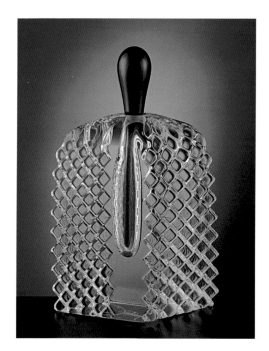

Architectural Perfume.

100

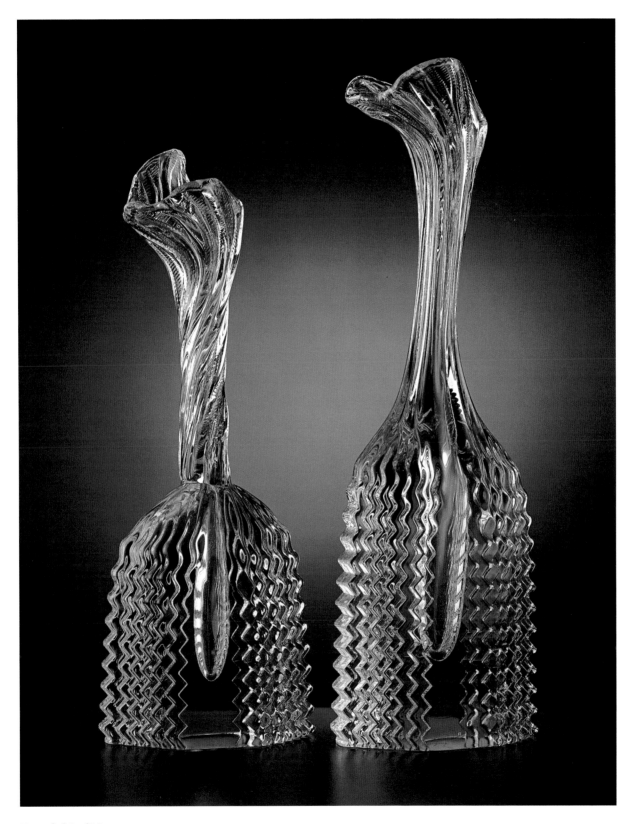

Extended Bud Vases.

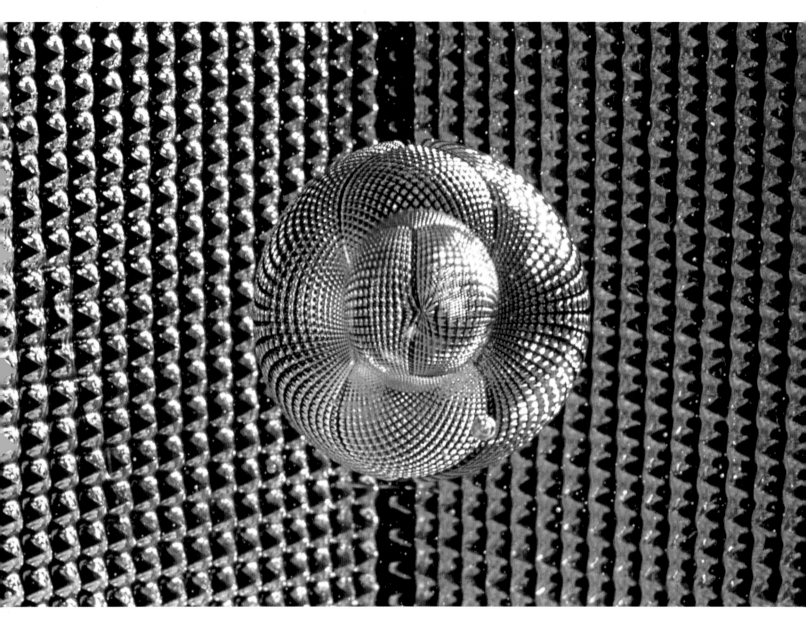

Laser Optic #2 (detail), collection of Corning Museum.

Bubble net.

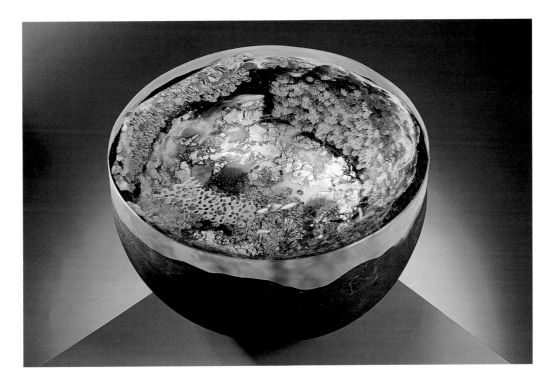

Black glass pendant, created in collaboration with Carla Caruso.

Cast portal with trapped planet.

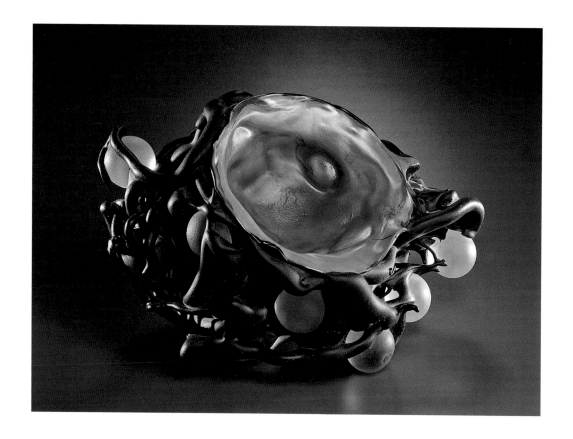

"Years ago, a friend gave me a small glass meteorite known as a tektite (from the Greek *tektos*, meaning molten). I had long admired the "perfect crystal" made by the Steuben glass factory in Corning, New York. Their glass is clear, colorless and without striations, bubbles or flaws of any kind. My little meteorite, on the other hand, was the polar opposite: a primeval blackened lump, pitted from its fiery journey through Earth's atmosphere. As I held it in my hand, it occurred to me that this object was truly perfect crystal—made in heaven before humans existed. Months later a geologist friend did a spectrographic analysis of my meteorite. I re-created the formula in my furnace the next day. The synthetic tektite glass is difficult to blow and manipulate; it seems to have a mind and a will all its own. The piece is finished when the glass and I reach some sort of compromise. Tektites are my perfect crystal."

Bird's-Nest Tektite.

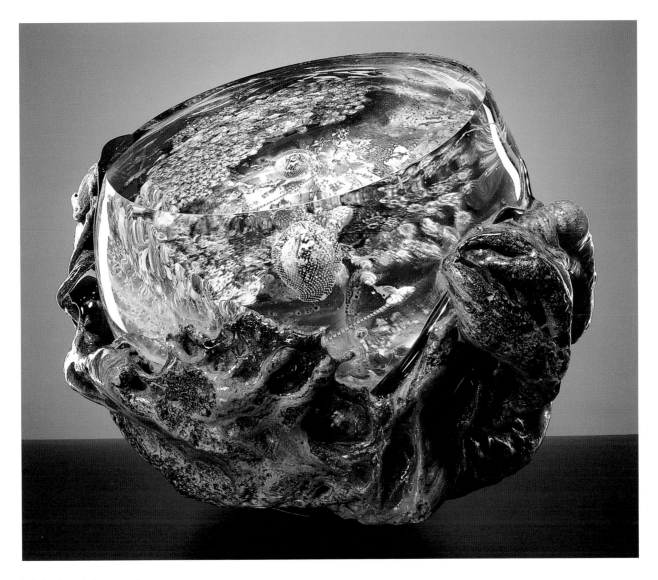

Tektite Portal, 85 pounds.

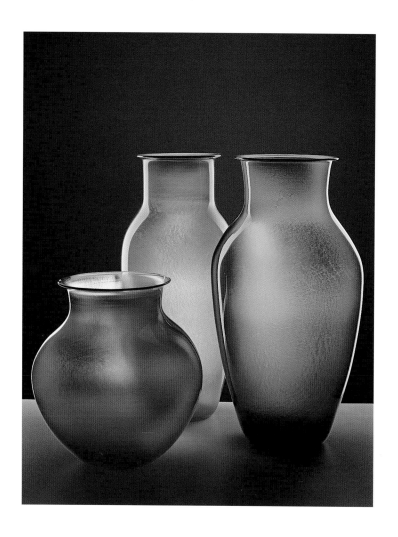

"Louis Comfort Tiffany's glass was incredibly popular at the turn of the century, but by the early 1950s, my grandmother had given most of her collection to the local church's Sunday tag sales. I was just a kid when I found several forgotten peacock blue iridescent vases in a trunk in her attic. Learning to make iridescent glass was high on my list when I began to blow glass in 1971; I experimented with every metallic oxide I could get my hands on. On a research visit to the Corning Museum's Rakow Library, I thought I discovered the secret to that glass. Tiffany himself would walk into the factory, open the furnace door and throw a 20-dollar gold coin into the furnace: more than a month's wages for his workers. When I

Iridescent vases.

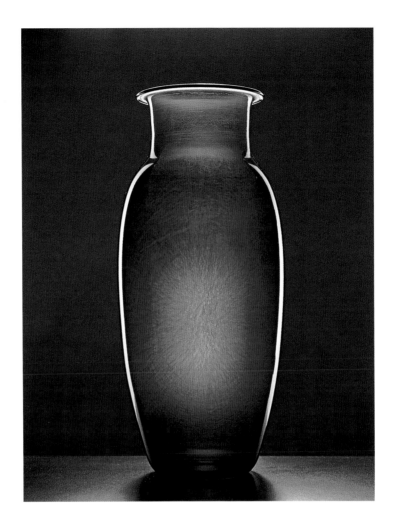

finally figured out how to do it, I realized that Tiffany was misleading everyone. In fact, metallic silver, not gold, was added to achieve the peacock blue iridescence on the outside of that classic work. For a while, I made my own iridescent glass. No matter how hard I tried, my attempts to be original always looked like something done at the turn of the century. In the end, I gave up and put the formula on a shelf. Eventually, I resurrected the formula to use on the inside of my tektite meteor work, and that led to my making a series of iridescent vases that have a different and more delicate iridescence on the interior of the vase. It is ironic that these vases are now sold exclusively through Tiffany & Co."

Gold ruby iridescent vase.

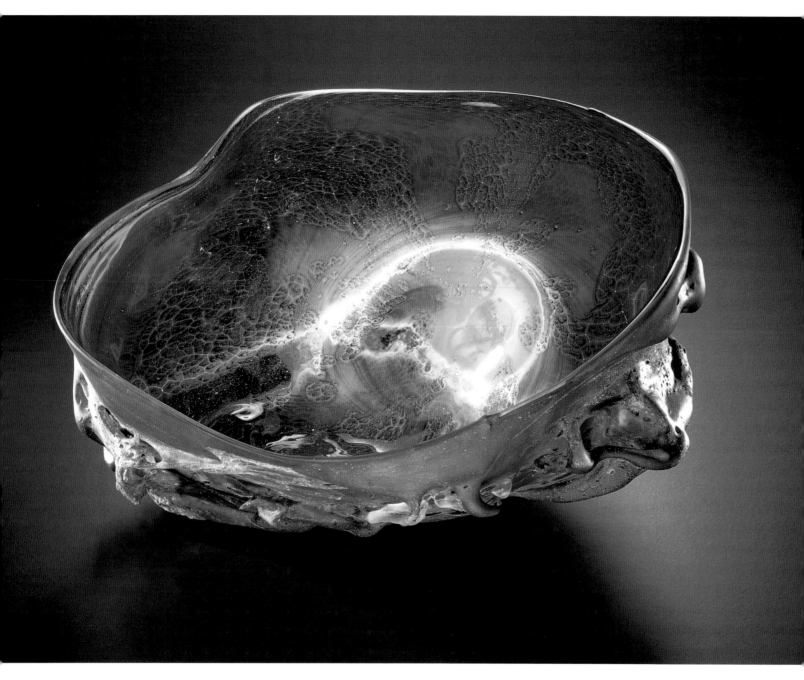

New Mexico Tektite.

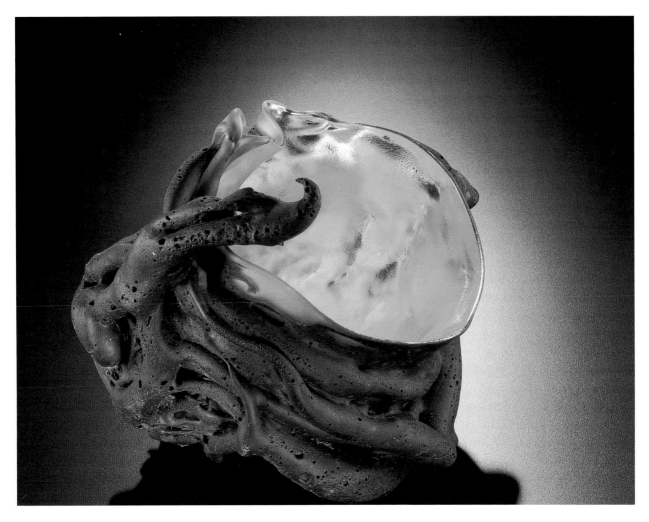

Gold Interior Tektite.

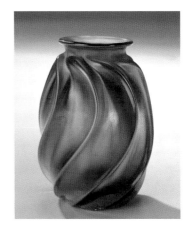

Iridescent Twist Vase, an early piece with iridescent technique used later for tektite interiors.

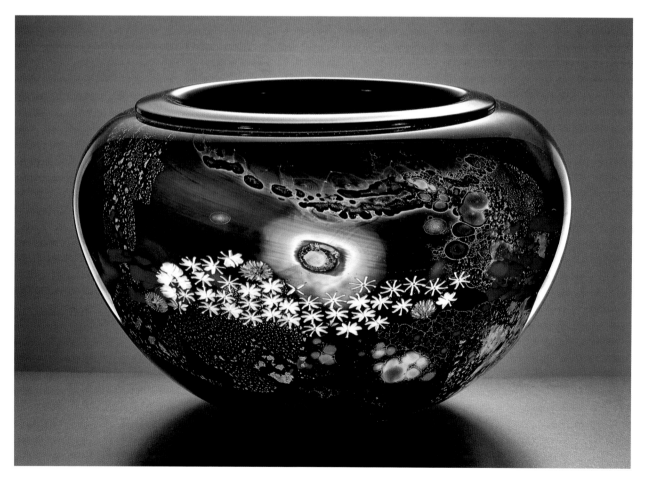

Inhabited Vase.

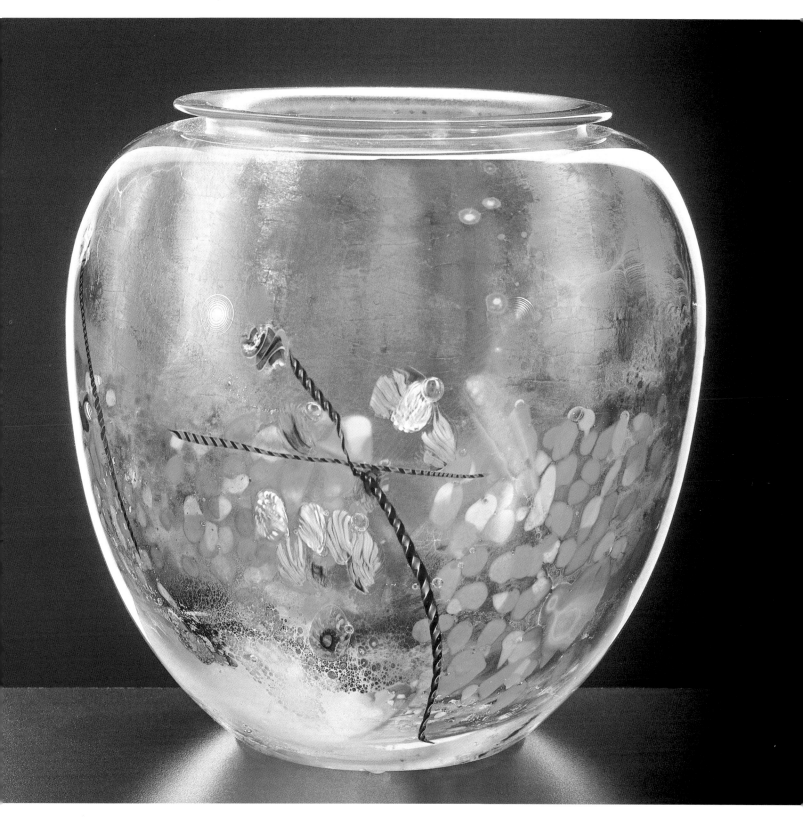

Inhabited Vase.

"Keeping a balance between creating one-of-a-kind work and multiples is like being on a swing for me. Physically they are similar, just different ways to practice my craft. Having the perseverance to make multiples hones my technical skills. Then, after I get bored doing repetitious work for a week or two, I swing back and am excited about doing more complex one-of-a-kind objects. The challenge and satisfaction of one-of-a-kind work in turn gives me the patience to blow the same type of object again and again when I return to multiples.

Sometimes I think production work is harder. I have to embrace the boredom that the repetition brings, and at the same time create an intriguing object that someone will wish to purchase. I like working with the material over and over again, each time changing the colors, pattern or design in an effort to make the "perfect" piece. When, for example, I make a vase, I focus on the color, size and thickness of the side walls and base; the resolution of the lip; the relationship between the lip and the rest of the vessel; the balance, functionality and overall look of the piece — all are vital to perfection. When I haven't made a particular kind of object for a while, it takes a day or two to get back into the rhythm. After a few days, boredom sets in; at that point I can lose interest and make terrible work or I can begin to push the material and start to have fun. Exploring often leads to something I can use in my one-of-a-kind pieces.

One-of-a-kind work requires a different kind of energy. I've got more ideas than I could possibly make in my lifetime. Sorting through those ideas is a task in itself. I have to factor in the resources I need: equipment, assistants, materials (if I'm using something in addition to glass, as in my *Copper Basket* series) and time. Time spent on a one-of-a-kind object is time away from other work, so I have to factor that in as well. I will often spend my weekends or vacation, when the studio is empty, doing preparatory or experimental work. That is the time when I first started welding my baskets, making spaceships with a torch, laying out murrini patterns for cast plates or using my milling machine or lathe to make forms for cast sculpture.

I like collaborating because there's such a different dynamic. The glass-and-stone series made with Neil Homstead was theoretically impossible, but we thought why not try? The underwater series with Joyce Roessler was fun because so many people already thought my planets looked aquatic. Jewelry with Carla Caruso was a challenge of scale for me because my work is typically much larger. I have recently begun to work with Harry Besett and Ken Leslie to create more surreal painted objects. I like sharing my vision with another artist without knowing the outcome ahead of time. The unpredictability and surprise keep me engaged."

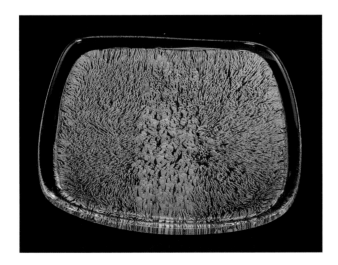

Cane plate.

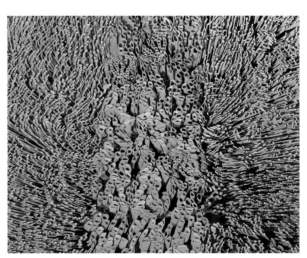

Cane plate (detail).

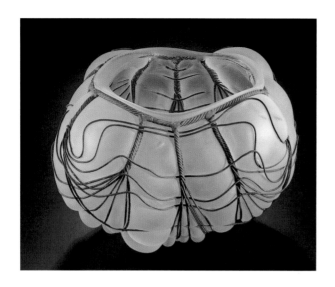

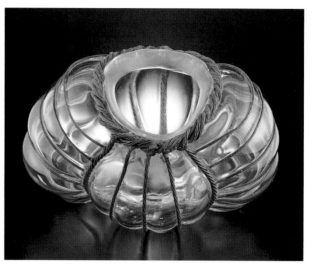

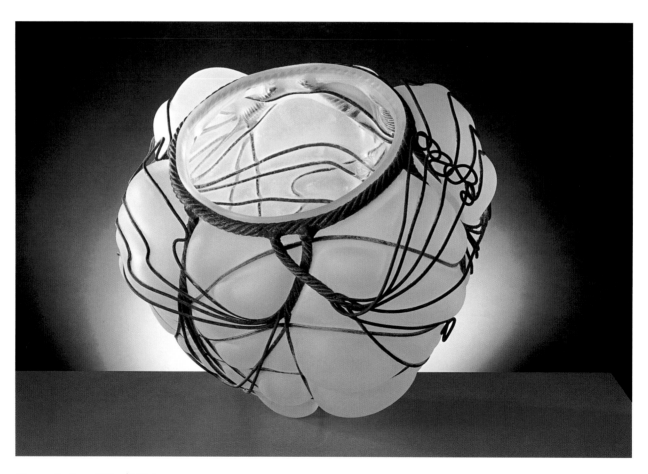

Copper Baskets, 12" to 24" diameter.

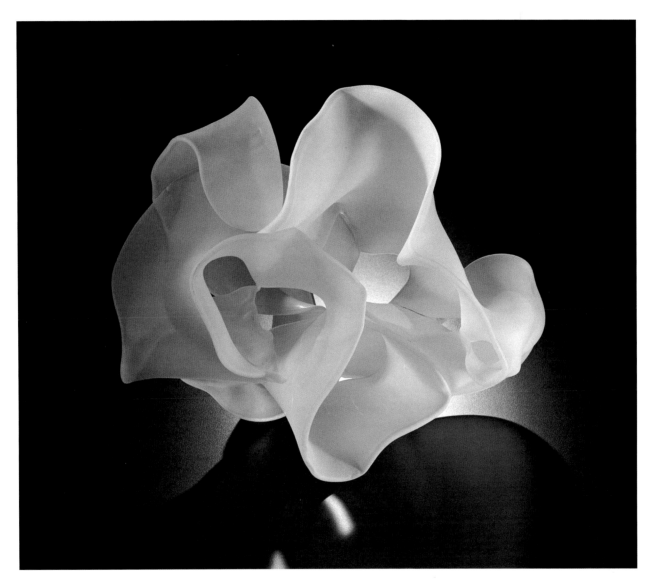

Ribbon Sculpture.

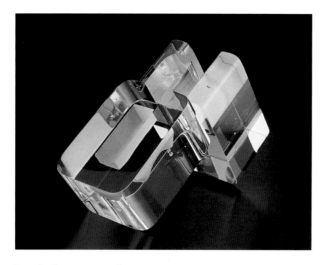

Interlocking cast sculpture.

Cast treasure box with gold interior.

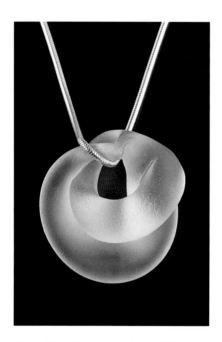

Crystal Pendant, created in collaboration with Carla Caruso.

Cast sculpture utilizing machined plaster mold.

Double Rock, created in collaboration with Neil Homstead.

116

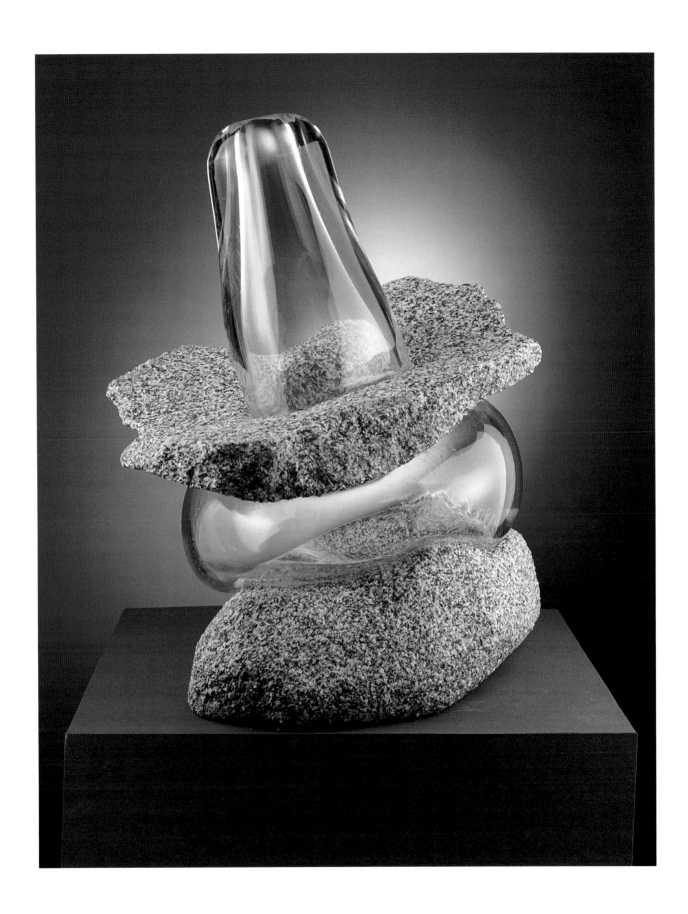

"My dad and I spent Saturdays together doing everything from shopping to art projects, and occasionally it could be a little scary. We'd sometimes go to the train yards, sneak under the fence where the guard couldn't see us and then climb on or under the steam locomotives and the sleek new diesels. They were terrifying machines from the perspective of a 10-year-old, but I loved my dad's explanations about how they worked.

Sometimes we would make 'moonscapes.' We'd mix a huge bag of plaster in a bucket in the kitchen sink and carefully pour the thick white liquid into one of my mom's baking pans. As the plaster began to harden, we would fill eyedroppers with food coloring and drip the colors from a ladder directly onto the plaster below. The coloring made remarkably lifelike craters that remained frozen when the plaster solidified. My mom made us move this activity to the basement after one too many colorful spills on the kitchen floor."

Moon craters. NASA photo.

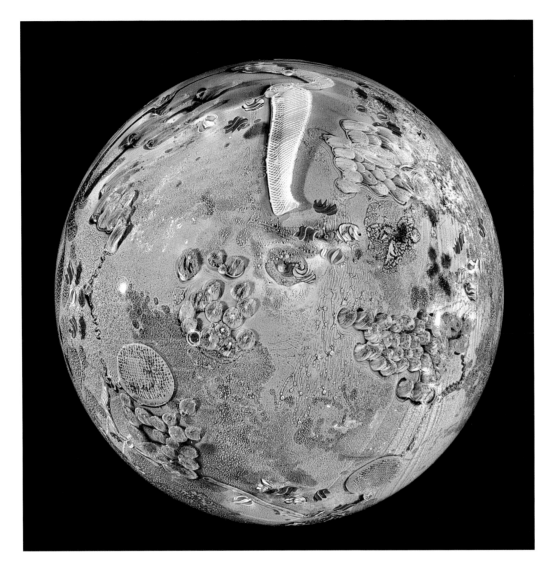

Megaplanet.

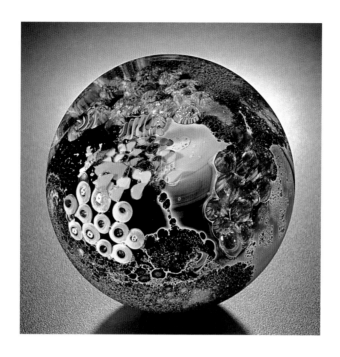

"In 1976 I discovered several handmade marbles outside my kitchen door that had probably been lost by children a generation earlier. The marbles were still just as bright and colorful as they were on the summer afternoon they were lost. The discovery made me think about the longevity of glass—there are so many priceless glass objects in museums around the world that spent eons buried in the ground before an archaeologist happened upon them. In 1976 no museum had acquired my work. I thought, why not hedge my bet?

I began to hide my planets—first I hid them near my house, and later I brought them with me to leave behind whenever I traveled. I've left planets in mundane places, and now, thanks to the Internet and the Infinity Project, people around the world are making sure that planets will be found in truly exotic locations around the globe. Some are meant to be discovered quickly, perhaps by someone who will wonder what it is or what it was meant for. Others are likely to lie hidden for centuries. I like the idea of people from a future time studying these little worlds, searching the surface for clues to their meaning."

Space Planet, collection of Moritex Corporation.

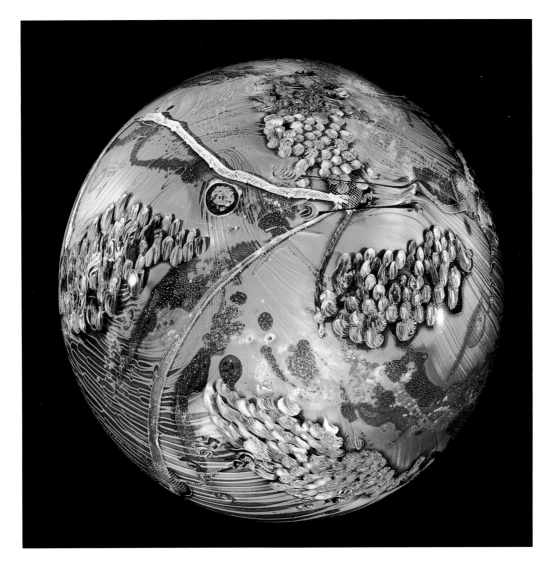

Megaplanet.

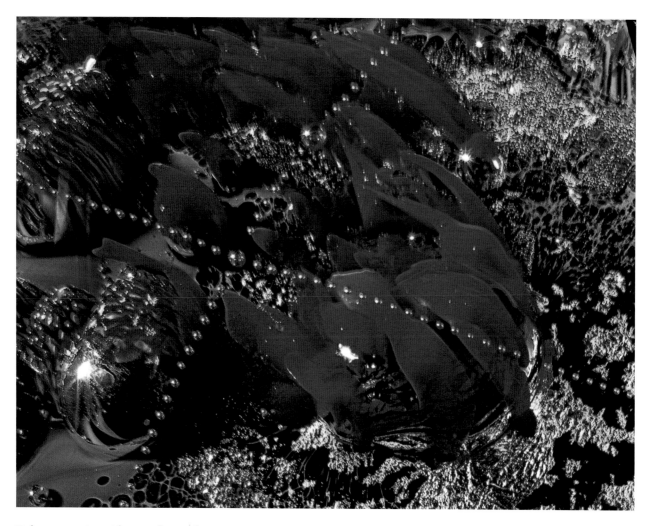

Ruby mountains with spaceship trails.

Megaplanet surface (detail).

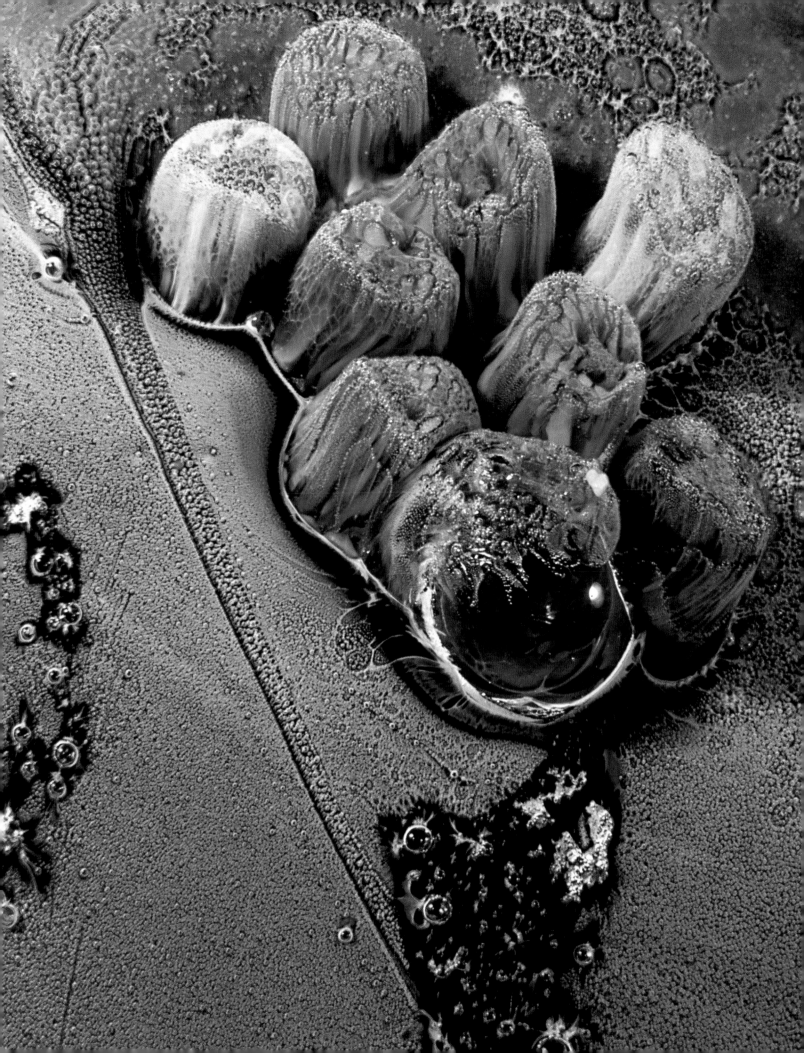

CHRONOLOGY

1949 Josiah James Linsly Simpson, Jr., son of Jim and Norma Simpson, is born in New Haven, Connecticut. ▪ Lewis Legbreaker born in Wagga Wagga, Australia, direct descendant of penal colonists.

1952 Brother Randy born.

1955 Brother Kim born.

1957 Josh publishes the *Truesdale Lake News*, circulation 350. Story is picked up by newspaper chain. Publishing career lasts for the summer.

1958 Josh and Lewis nearly arrested for illegal fireworks possession.

1963 Josh and Lewis build a series of night-launched eight-foot-tall hot air balloons made of rice paper and powered by propane and gasoline. Seven confirmed UFO sightings that summer dismissed by Air Force officials as "glowing swamp gas."

1965–1968 Attends Kent School in Kent, Connecticut. Begins ceramic career.

1968–1973 Attends Hamilton College in Clinton, New York. Learns to blow glass at Goddard College in 1972. Gives up promising career as spoon player in Celtic and bluegrass bands.

1972 Builds his first studio in the Northeast Kingdom in Vermont. Lives in teepee, trades glass for one thousand pounds of dried chickpeas. ▪ Attempts to borrow $5,000 to purchase studio land; bank executive mistakenly thinks he blows "grass" for a living and has him removed from premises by security guards.

1973 Lives in Datsun pick-up truck for the summer. Builds second studio in Northford, Connecticut. Main source of protein: chickpeas.

1974 Attends ACC Rhinebeck Craft Show. First gallery order for glass.

1976 Marries and moves to Shelburne Falls. Receives tarantula, Blanche, as wedding present from high school friend Bart. ▪ First planets

made to entertain visiting school children. Main source of protein still chickpeas.

1977 Rosalynn Carter commissions wine goblets for the White House. Chickpeas stricken from diet. ▪ First IRS audit triggered when gas consumption in glass studio exceeds total propane use at all McDonald's restaurants in Western Massachusetts. Of the two enterprises, only McDonald's shows a profit that year. IRS auditor becomes glass collector.

1978 Lewis Legbreaker establishes Lewis Legbreaker Poisonous Chemical Co., Inc. ▪ Josh hides first planets for kids to find in town.

1979 Included in Corning Museum's *New Glass Review* traveling exhibit.

1980 Begins collection of coin sorting mechanisms from old vending machines.

1983 Son Josiah is born; Josh renovates section of barn for quiet studio in vain attempt to find a place to think.

1984 Josiah's first spoken word: "Hot!" ▪ Josh meets Swedish photographer Tommy Olof Elder; start of lifelong professional collaboration. ▪ Member and chair of Shelburne Falls planning board, five-year term.

1985 Wins Juror's Award, *Artists Look at Earth*, National Air and Space Museum, Washington, DC. ▪ Helps found Craft Emergency Relief Fund. Serves as Board president until 1992.

1987 Josh and wife split amicably.

1988 First international exhibit at Galerie Heidi Schneider in Zurich, Switzerland. ▪ Fire destroys garage and threatens residence; Simpson rescues his toothbrush, his grandfather's watch, and 1556 copy of *De Re Metallica*. ▪ Nicholas Sant Foster buys planet at Corning Museum; begins close-up photography collaboration with Josh.

1989 Josh diagnosed as organizationally impaired. Begins lifelong organizational collabora-

124

tion with Karen Krieger, who brings order to chaos. ▪ Teaches at Penland School of Crafts, Penland, North Carolina. ▪ Purchases scenic Patten Hill property in Shelburne for the Massachusetts agricultural preservation program.

1990 Josh meets Air Force Captain Cady Coleman. ▪ Teaches at Haystack Mountain School of Craft, Deer Isle, Maine.

1991 Exhibits at George Walter Vincent Smith Museum, Springfield, Massachusetts; and Arnot Art Museum, Elmira, New York. ▪ Begins four-year collaboration with Carla Caruso to make glass jewelry. ▪ Meets Mr. Y. Morito, president of Moritex Corporation; challenges Josh to make the "largest planet" for the Sphere Museum in Tokyo; first of many trips to Japan.

1992 Elected president of Glass Art Society for two years; serves on board for seven years. ▪ Learns to fly. ▪ Cady chosen as Mission Specialist NASA Astronaut; Josh overcome with jealousy.

1993 Guest lecturer at Aichi University, Aichi, Japan, and the Tokyo Glass Art Institute, Tokyo, Japan. ▪ Collaboration with Neil Holmstead to make glass blown into granite rock sculpture. ▪ Start of collaboration with Joyce Roessler to make aquatic planets.

1995 Cady's first space shuttle flight. Simpson planet goes into orbit.

1997 Josh and Cady marry. Second tarantula, Hairy, arrives from friend Bart. ▪ Teaches at the Studio at the Corning Museum, Corning, New York; and Wanganui Polytechnic, Wanganui, New Zealand. Visits with Lewis's relatives.

1998 *Visionary Landscapes* opens at the Bruce Museum, Greenwich, Connecticut.

1999 Cady's second space flight. ▪ Josh receives digital "pick and place" robot bead machine from Mr. Morito, who challenges him to find new uses for it. First successful image: Elvis.

2000 Josiah gets driver's license. Second son, Jamey, is born, allergic to chickpeas. Life is good.

PUBLIC COLLECTIONS

American Craft Museum, New York, New York
Bergstrom-Mahler Museum; Neenah, Wisconsin
Brunnier Museum; Ames, Iowa
Chrysler Museum; Norfolk, Virginia
Corning Museum of Glass; Corning, New York
Dartmouth College Hood Museum; Hanover, New Hampshire
Fuller Art Museum; Brockton, Massachusetts
George Walter Vincent Smith Art Museum; Springfield, Massachusetts
Hamilton College Emerson Gallery; Clinton, New York
Mint Museum; Charlotte, North Carolina
Museum Bellerive; Zurich, Switzerland

Museum of Decorative Arts; Prague, Czech Republic
Museum of Fine Arts; Boston, Massachusetts
Nelson Museum of Art; Tempe, Arizona
Peabody Essex Museum; Salem, Massachusetts
Renwick Gallery, Smithsonian Institution; Washington, DC
Royal Ontario Museum; Toronto, Canada
The Alcorcón City Museum of Glass Art; Spain
The Museum of Arts and Sciences; Macon, Georgia
U.S. State Department
Yale University Art Gallery; New Haven, Connecticut

ACKNOWLEDGMENTS

When Toni Sikes at GUILD.com asked me if I would be interested in doing a book about my glass, I thought it was a great idea — especially when she told me that I had 15 months to organize everything. To a person for whom long range planning is deciding what to have for dinner, 15 months seemed like forever. In fact, the time passed in a heartbeat.

The creation of this book has been much like the making one of my megaplanets: it has taken the effort and coordination of an extraordinary group of people whose creativity, imagination, goodwill and perseverance all combined to make an idea tangible.

I'd like to thank my studio team — they make difficult projects easy and insurmountable ones plausible. The folks at GUILD.com have been supportive and generous, especially Katie Kazan, who managed to remain calm even as deadlines passed. Andy Chaikin was great. I've always loved his books about NASA and space exploration, and was so pleased when he took time to work on this project. Mr. Y. Morito has been my friend since he appeared in my studio so many years ago. His child-like spirit and technical wizardry have always been an inspiration. It was Mr. Morito's challenge that resulted in my first megaplanet attempt. Karen Krieger is the most clear-thinking and organized person I know. She always managed to keep me on track (and I have scars to prove it). Without Karen, this book never would have happened. I would especially like to thank the photographers who generously gave permission to include their images in this book. Their work is the link between my glass and the rest of the world.

To my parents, Jim and Norma, thanks for encouraging me when I was very young to reverse-engineer almost every mechanical thing in the house. I still owe them tools, watches and appliances that I couldn't get back together. They have always been the best, even on the day I told them I wanted to be a glass artist. Randy and Kim, my younger brothers, are the nicest guys anywhere.

My son Josiah, who is nearly grown up and about to embark on his own independent adventures, has always been supportive and empathetic even when our needs were in conflict. My infant son Jamey can stop me in my tracks with a smile — he's also made me realize how truly precious sleep can be. Cady Coleman is my best friend, my sweetheart and my wife — the best wrong number I ever answered. Although I was making my planets long before we met, I appreciate her perspective of our Earth and the heavens around us. Her way of looking at science has changed the way I look at art.

Thanks to Jonathan, who inadvertently showed me how precious life really is, and to my old friend Lewis, who has proven that even shy people can find happiness.

Josh Simpson

The earth from space. NASA photo.

"Josh Simpson creates planets that are mid-way between the micro and the macro. They have some of the mystery of the atomic level and much of the complexity of the cosmic, Mercury, Io or Titan. His work has a uniqueness that is fascinating to all."

Neil A. Armstrong
Astronaut
Apollo 11 Commander

"Through the portals of the universe that Josh Simpson has created, we can experience the excitement of visiting new worlds—and the thrill of discovery.

Voyaging toward the Earth aboard the *Yankee Clipper* after my walk on the moon during Apollo 12, I could look out my spacecraft windows and, in one direction, I could see the Earth, in the other direction, the moon. I suddenly realized that I could stretch out my arm and, in a sense, hold each unique world in the palm of my hand.

Josh Simpson's imagination takes us on an awe-inspiring, three-dimensional journey to planets and other worlds unknown. These intimate glass orbs of mysterious beauty invite scrutiny, revealing the wonder and invention of a brilliant and innovative artist. As humanity continues to explore new worlds, these yet-to-be discovered places may be reflected in Simpson's intricately landscaped Planets that we can, today, hold in our hands.

Josh Simpson's visionary landscapes have the silent power to make us aware of how magnificent, rich, and wonderfully complex the universe around us can be. . . ."

Alan Bean
Apollo 12 and Skylab 3 Astronaut
Explorer Artist